Quilting with My Sister

I5 Projects to Celebrate Women's Lives

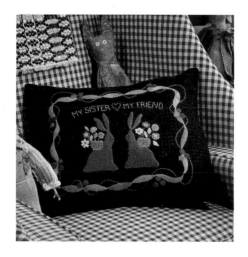

Barbara Brandeburg
and Teri Christopherson

Martingale®
& COMPANY

That Patchwork Place® is an imprint of Martingale & Company®.

Martingale & Company
20205 144th Avenue NE
Woodinville, WA 98072-8478 USA
www.martingale-pub.com

MISSION STATEMENT

Dedicated to providing quality products and service to inspire creativity.

ACKNOWLEDGMENTS

We would like to acknowledge our talented quilters: Michelle Allen, Barbara Jones, Janet Murdock, and Vicki Stratton.

Printed in China
09 08 07 06 8 7 6 5

Library of Congress Cataloging-in-Publication Data

Brandeburg, Barbara.
 Quilting with my sister : 15 projects to celebrate women's lives / Barbara Brandeburg and Teri Christopherson.
 p. cm.
 ISBN 1-56477-530-5
 1. Patchwork—Patterns. 2. Quilting.
 3. Appliqué—Patterns. 4. Women in art.
 I. Christopherson, Teri. II. Title.
 TT835 .B653 2004
 746 . 46—dc22
 2004010489

CREDITS

President • Nancy J. Martin
CEO • Daniel J. Martin
Publisher • Jane Hamada
Editorial Director • Mary V. Green
Managing Editor • Tina Cook
Technical Editor • Laurie Bevan
Copy Editor • Melissa Bryan
Design Director • Stan Green
Illustrator • Laurel Strand
Cover and Text Designer • Shelly Garrison
Photographer • Brent Kane

SPECIAL THANKS TO:

Kathy Parker, Eileen Softeye, and Laurie Giddings for letting us photograph many of the projects in their lovely homes.

Contents

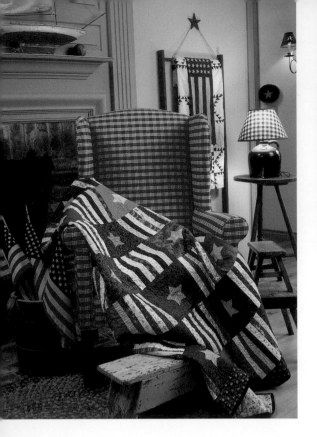
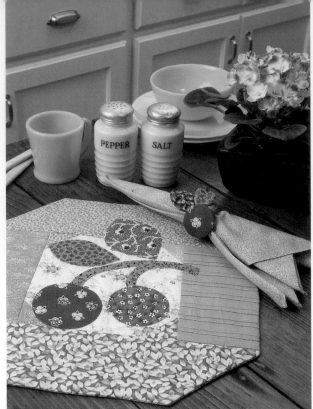
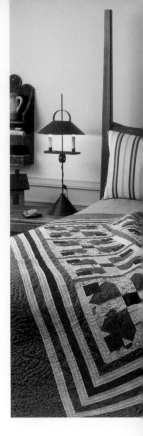

Introduction

Whether it's baking brownies, shopping for new shoes, or sewing a quilt, everything is more fun with a mother, daughter, sister, or friend along for the ride.

For over a decade, we have designed quilts for our pattern businesses, Cabbage Rose and Black Mountain Quilts. It has been a wonderful journey, but the best part is that we've been able to do it together as sisters. We don't live close to each other, but we talk on the phone nearly every day and travel to the trade shows together. Our mother was right—work is more fun when it's shared with a friend.

We grew up in a family of six sisters and one brother, so there were always plenty of playmates around. Our mother threw away our television when we were in grade school, a traumatic experience at the time but something for which we are grateful now. If we complained of boredom, she said, "Bored people are boring people." So we developed our creative talents—sewing,

drawing, painting, gardening, reading, writing, and carpentry. There was a craft project going on in every room. And, of course, we learned to quilt.

Our mother's quilting technique was more resourceful than artistic. She cut up leftover dressmaking fabric into simple squares—bright polyester fabrics that screamed 1960s. She backed her quilts with inexpensive bed sheets and tied them with red yarn. We still have a few of those brilliant quilts hanging around, and we treasure them.

As sisters, we did everything together, and quilting was no different. When the oldest, Carol, got married, we met in secret to make her wedding quilt, hiding the quilting frame in the garage before she got home from work. We learned what generations of women have learned before us: that quilting bees are a great excuse to get together to laugh and talk and be productive, all at the same time.

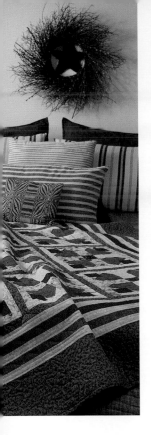
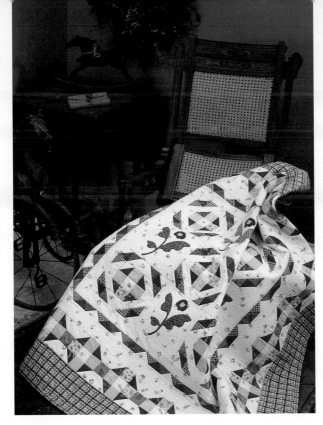
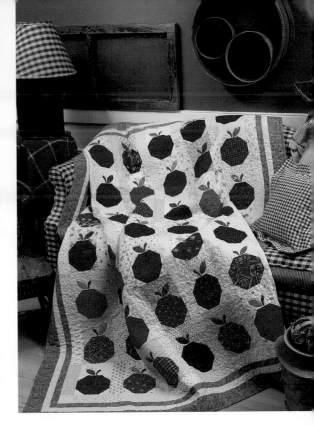

As quilters, we feel as if we belong to a second family of sisters—thousands of them! We smile whenever we spy a fellow quilter in the world at large, her identity revealed by a telltale license plate or key chain. Entering a quilt store is like going home, and the women we meet inside—handling fabric with glazed expressions on their faces—feel like old friends. We share an understanding of strange phrases, like "fat quarter," "drunkard's path," and "fusible web." We come from diverse towns and backgrounds, but are united by a common passion for cutting up beautiful fabric and sewing it back together again.

Ten years ago, we got the wild idea of publishing our original quilt designs and selling them to quilt stores. We flew to the industry trade show in Houston, Texas, with no clear idea of what we were doing or how to do it. We were terrified as we stepped off the airplane. Then we noticed the other women sharing our hotel shuttle—they carried quilted tote bags and sported flying geese pins on their lapels. By the time we reached the hotel, we were gabbing with these strangers like schoolgirls.

We have wanted to write this quilt book together for years. We thought it would be a great way to celebrate the wonderful women in our lives—mothers, daughters, sisters, and friends who have supported us along the way. We wanted to design quilts that would honor the important times in a woman's life—love and friendship, babies and children, creating a comfortable home, memorable moments, and decorating for the holidays.

We hope this collection inspires you to reflect on the meaningful women in your own life. We are so grateful for the support and encouragement we have felt from quilters like you over the years—friends we have yet to meet. Keep on quilting; we know we will.

Barbara Brandeburg Teri Christopherson

Quiltmaking Basics

We've always believed that quilting should be more about fun than perfection, but following a few basic rules will improve your odds of success. Here are some quilting techniques that have worked well for us.

Selecting and Preparing Your Fabrics

Use only high-quality, 100%-cotton fabrics for quilting. Cotton fabrics hold their shape and are easy to handle, while blends are sometimes difficult to sew and press accurately.

YARDAGE REQUIREMENTS

Quantities for all quilts in this book are based on 42"-wide fabrics. We assume at least 40" of usable width after preshrinking, and we specify a minimum width only for a few quilts where it's truly critical.

PREPARING FABRIC FOR QUILTING

Always prewash fabrics to preshrink and test for colorfastness. Never be tempted to skip this step, no matter how eager you are to start cutting those gorgeous fabrics.

Dark colors, bright colors, and light colors should be washed separately. Reds are especially prone to bleed and may require several washings. You can add a cup of vinegar to the cold rinse water to cure bleeding in some fabrics, or ask the staff at your local quilt store to recommend a product that helps set colors. Don't skimp—wash and rinse until you're certain all the dyes are set, or, if still in doubt, replace the fabric with another.

Press your prewashed fabrics, whether yardage or scraps from your stash, before you begin cutting.

Materials and Supplies

Sewing machine. You'll need a reliable machine with a good, sturdy straight stitch for piecing. If it has a programmable blanket stitch and other decorative stitches, appliquéing will be much easier. For machine quilting, a walking foot or darning foot is a must.

Rotary-cutting tools. Nothing makes patchwork go faster than the right cutting tools. Use a rotary cutter and cutting mat plus clear acrylic rulers in commonly used sizes. (Rulers sized 6" x 6", 6" x 24", and 12" x 12" will get you started.)

Needles. For piecing and appliqué on your machine, a size 70/10 or 80/12 needle works well. If you choose a heavier-weight thread for the appliqué, use a machine embroidery needle. For hand appliqué using embroidery floss, you will need embroidery needles.

Pins. Straight pins with glass or plastic heads are easy to handle and easy to keep track of while you're working. Silk pins are a little more expensive, but they're exceptionally thin and can slide through fabric easily. If you use safety pins to baste your quilt layers together, be sure they are rustproof. If you are interrupted and don't get to the quilting right away, you don't want to find that humidity has caused the safety pins to rust and ruin your project.

Threads. Use high-quality mercerized cotton thread for piecing, appliqué, and quilting. Save those bargain-table poly-cotton threads for basting. For embroidery, use the best-quality floss you can afford.

Batting. We prefer battings that are 100% cotton or mostly cotton. A batting with an 80% cotton–20% polyester blend has a little more loft

but still gives a traditional look and feel. Teri likes to wash her finished quilts in the washer to remove markings, and then dry them on a warm setting in the dryer to shrink the batting, resulting in a slightly wrinkled quilt with a vintage look.

Scissors and seam rippers. You'll need a really good pair of scissors for cutting fabric only. Use another, cheaper pair for template plastic, paper, and cardboard, and keep a small pair of embroidery scissors with sharp blades for snipping threads. A seam ripper will come in handy, too— no one can piece hundreds of blocks without a single mistake!

Template plastic. Sheets of clear or frosted plastic (available at quilt shops) are needed to make durable, accurate templates.

Fusible web. This iron-on adhesive product makes any fabric fusible. Refer to the manufacturer's directions when applying fusible web to your fabrics. For more information, refer to "Using Fusible Web" on page 9.

Freezer paper. Freezer paper is coated with plastic on one side and can be ironed onto fabric without damaging it. The paper sticks temporarily and can be removed and reused. Freezer paper is often used to help make perfectly shaped appliqué pieces, and you can find it at your local grocery store.

Marking utensils. When it's time to mark a quilt top, Teri uses a water-soluble fabric marker, which washes out easily with water. Barbara prefers using white pencils on medium and dark fabrics, and a regular pencil on light fabrics. Whatever you use, test it first on scraps of fabric to make sure the marks can be removed easily when the time arrives. Ask the staff at your local quilt shop for recommendations.

Rotary Cutting

A great time-saver, rotary cutting also makes precision cutting easier. We'll give just a brief overview here. To learn all the ins and outs of rotary cutting, read Donna Lynn Thomas's book *Shortcuts: A Concise Guide to Rotary Cutting* (Martingale & Company, 1999).

1. Match selvages and align crosswise and lengthwise grains as much as you can. Place the fabric on the cutting mat, folded edge next to you. Place a square ruler on the fold, and then place a long ruler to its left. The long ruler should just cover the raw edges of the fabric.

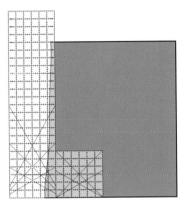

2. Remove the square ruler so that you can cut along the right edge of the long ruler. Always roll the rotary cutter away from you. Discard the uneven scrap.

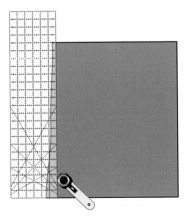

3. To cut strips, align the ruler mark for the required strip width with the fabric edges just squared. Cut along the ruler's edge, rolling the tool toward the selvages.

4. To crosscut strips into squares, align the ruler mark for the required measurement with the left edge of the strip. Cut along the ruler's edge. Move the ruler, align it again for the required measurement, and repeat until you have the number of squares needed.

Piecing

All cutting directions in this book include ¼" seam allowances in the measurements for patchwork, blocks, and borders—every piece except appliqués. It is vitally important to maintain an accurate ¼" seam: if 5 blocks are different in size from the other 25 blocks, they won't fit together correctly. If the blocks are all the same size but the size is incorrect, then sashes, borders, and other pieces won't fit properly.

We piece by machine, but if you piece by hand, mark a light guideline for seams on the fabric and keep a ruler by your side for checking accuracy.

ASSEMBLY-LINE MACHINE PIECING

To piece by machine, first establish a seam guide exactly ¼" wide. Your machine may have a special foot measuring ¼" from the center needle position to the edge of the foot. Otherwise, create a seam guide by placing a length of tape or moleskin ¼" from the needle, as shown.

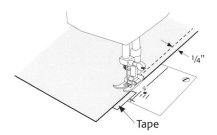

The fastest way to piece a large number of blocks is to match up identical pieces to be joined at one time. This is often called chain piecing, but we call it assembly-line piecing.

1. Set your machine for 12 stitches per inch. Place the first two fabric pieces to be joined under the needle and sew from edge to edge. Stop at the end of the seam, but do not cut the thread.

2. Feed the next two fabric pieces under the presser foot, sew from edge to edge, and stop. Feed the next two pieces, and so on, without cutting the thread. All seam ends will eventually be crossed by another seam, so there is no need to lock your stitches.

3. When all identical pieces have been stitched, clip the threads to separate them.

PRESSING

In quiltmaking, press every seam you sew. The general rule is to press seams to one side, usually toward the darker color. We will occasionally tell you to press seams open because several layers create too much bulk. Unless the directions specify otherwise, press all seams flat from the wrong side, and then press them in one direction from the right side. Be careful not to pull or stretch the pieces when pressing.

Appliqué

We use fusible web for the appliqué in our projects (except for the pillow project "My Sister, My Friend"). The technique is easy and allows us to work quickly. We trace the patterns onto fusible web, iron them to the wrong side of the fabric, cut out the pieces, peel off the paper, and position the pieces. Then we sew over all the edges with a hand or machine blanket stitch or embroidery stitch, keeping the stitches close together so that the quilts will be washable.

Because we use fusible web, the appliqué patterns in this book are reversed from how they will appear in the quilt (except for the pillow project "My Sister, My Friend") and do not include seam allowances. If you appliqué by hand without fusible web, you will need to reverse the templates and add a seam allowance.

MAKING A TEMPLATE

Use clear or frosted template plastic for durable, accurate templates. Place the template plastic over the pattern and trace with a fine-tip permanent marker. Cut out along the lines and mark the piece name and grain line (if applicable).

USING FUSIBLE WEB

Use a good-quality, paper-backed fusible web product. There are many brands on the market; if you haven't already found one that you like, ask the staff at your local quilt shop to recommend a lightweight web for the fabrics you're using. (*Note:* We've calculated the amount of fusible web needed for each project based on a 17" width. Some products come in 12" or 20" widths as well, so purchase accordingly.)

The patterns in this book are reversed for tracing onto fusible web, except for the pillow project "My Sister, My Friend," which does not use fusible web.

Manufacturer's instructions vary for different fusible web products, but here are some general steps to follow. Try it—it's easy and fast and it produces a beautiful quilt. You might never appliqué by hand again.

1. Trace the pattern outline onto the paper side of the web, repeating for as many pieces as are needed from one fabric. (If you need eight medium pink petals, trace eight petals onto fusible web.) Cut out the shapes, leaving approximately a ¼" margin all around (not a seam allowance—you'll trim this off in step 3).

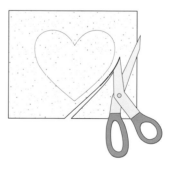

2. Fusible web can make medium and large appliqué shapes too stiff. To prevent this, after tracing the pattern to fusible web, cut out the center of the paper shape, leaving ¼" of paper inside the drawn line. This leaves ¼" of adhesive around the appliqué edge but the center of the shape will be free of adhesive.

Cut out center
of paper shape.

3. Fuse all the web shapes to the wrong side of the fabric by pressing.

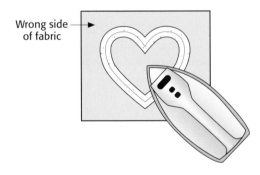

Wrong side
of fabric

4. Carefully cut along the traced lines.

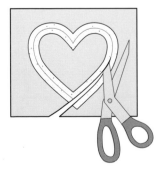

5. Remove the paper backing only when you are ready to fuse the appliqué to the background.

Position the appliqué, web side down, on the background fabric and press, following the manufacturer's directions.

Right side of
background fabric

Right side
of appliqué

6. Stitch around all raw edges, except those that will be enclosed in a seam later. This ensures that your quilts will survive washing. We usually use a machine blanket stitch, selecting matching thread for a subtle effect or contrasting thread for a folk-art effect.

EMBROIDERY STITCHES

Here are examples of the stitches we have used to do hand appliqué and embroidery embellishments on the projects in this book.

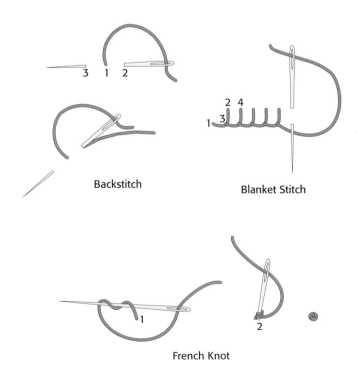

Backstitch

Blanket Stitch

French Knot

Assembling a Quilt Top

Always take the time to measure and square up completed blocks before assembling them in rows. Use a large square ruler to ensure that the blocks are all the same size and that they are actually the designated finished size plus ½" (to allow for a ¼" seam allowance on all sides).

If there are variations in size among your blocks, trim the largest to match the smallest. Be sure to square them, trimming all four sides, not just one side.

SEWING BLOCKS TOGETHER

Before sewing your blocks together, arrange them on the floor or a design wall. If the blocks are not identical, move them around until the busiest blocks are evenly balanced across the quilt. When block position is important, Teri likes to number the blocks, writing in the seam allowance with a water-soluble fabric marker so that she doesn't forget placement as she sews them together.

1. Sew blocks together into horizontal rows first. Press the seam allowances according to the project instructions and the pressing arrows in the illustrations. If no specific instructions are given, press the seams in row 1 in one direction, in row 2 in the opposite direction, and so on. Alternating the direction from row to row reduces bulk where seams meet.

2. Sew the rows together, usually working from the top to the bottom of the quilt. Match all block seams carefully for vertical alignment.

Follow the same steps if you're using sashing to join horizontal rows of blocks, alternating row 1, sashing strip, row 2, sashing strip, and so on.

ADDING BORDERS

To avoid wavy borders, we cut our border strips to fit the quilt top. Border measurements are included in the "Assembling the Quilt Top" section of every project. But since quilts don't always come out exactly the size they're supposed to be (especially large quilts), measure your quilt center before you add the borders. If your quilt center turned out smaller, you can trim your borders. If your quilt center turned out larger, you may have to add additional fabric and then cut to fit.

Here's the way we do it:

1. Measure the length of the quilt top through the vertical center. If it deviates more than ½" from the measurement given in the directions, adjust the side border length before cutting. Cut the side border strips, piecing as necessary. Mark the centers of the quilt sides and the border strips. Pin, matching center marks and ends. Sew in place and press.

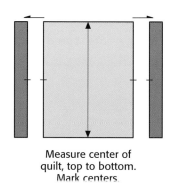

Measure center of
quilt, top to bottom.
Mark centers.

2. Measure the width of the quilt top through the horizontal center, including the side borders. Cut the top and bottom border strips, piecing as necessary. Mark the centers of the quilt and border strips. Pin, matching center marks and ends. Sew in place and press.

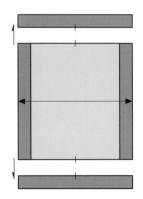

Measure center of quilt,
side to side, including borders.
Mark centers.

Quilting

If you plan to stitch in the ditch or outline quilt a uniform distance from seam lines, it probably isn't necessary to mark the quilting pattern on your quilt top. However, for more complex quilting designs, you'll want to mark the quilt top before assembling the layers.

To be sure you can erase the marks or wash them out, test your fabric marker on a swatch.

ASSEMBLING THE LAYERS

Cut your quilt backing 4" to 6" larger than the quilt top. For large quilts, you'll usually have to piece the backing either lengthwise or crosswise. Press seams open.

1. Spread the backing, wrong side up, on a flat surface. Anchor it with pins or masking tape, being careful not to stretch the backing along the raw edges.

2. Spread the batting over the backing, smoothing out wrinkles.

3. Place the pressed quilt top over the batting, right side up. Make sure the edges are parallel to the edges of the backing fabric.

4. Baste the three layers together. Starting in the center each time, baste diagonally to each corner.

5. Either continue basting in a horizontal and vertical grid or use rustproof safety pins to hold layers in place. Stitching lines or safety pins should be placed in rows 6" to 8" apart.

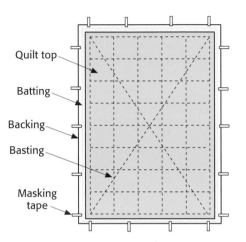

Quilt top
Batting
Backing
Basting
Masking tape

QUILTING BY HAND

Most quilters use a frame or hoop for hand quilting. Choose the smallest needle you're comfortable using, because it's easier to make small stitches with a small needle. Quilters favor short, sturdy needles called Betweens.

Aim for small, evenly spaced stitches, drawn firmly through all three layers. An excellent book to help you learn all about hand techniques is *Loving Stitches: A Guide to Fine Hand Quilting*, revised edition, by Jeana Kimball (Martingale & Company, 2003).

QUILTING BY MACHINE

All of our quilts are quilted by machine, and we highly recommend it. It takes much less time than quilting by hand, so you can start another quilt that much sooner.

You'll definitely need a walking foot for straight-line quilting, including stitching in the ditch and outline quilting. This foot is a remarkable help in feeding layers through the machine

without shifting or puckering. Your machine may have a built-in walking foot; if not, the staff at your local sewing machine store or quilt shop will help you choose the right attachment for your machine.

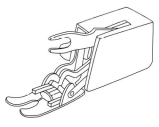

Walking Foot

Quilting in the Ditch Outline Quilting

For free-motion quilting, you need a darning foot. Drop the feed dogs on your machine and guide the layers of fabric along your marked design. Use free-motion quilting to stitch around appliqué shapes, to outline quilt a pattern in a print fabric, or to create stippling or curved designs.

Darning Foot

Free-Motion Quilting

Binding Your Quilt

The binding fabric requirements listed for each quilt in this book are for 2½"-wide strips cut across the width of the fabric as described here.

1. Cut fabric strips 2½" wide. You'll need enough strips to go around the perimeter of your quilt plus 10". Instructions in each project indicate the number of strips you'll need.

2. Sew strips end to end, right sides together, to make one long strip. Join strips at right angles and stitch diagonally across the corner. Trim and press the seams open.

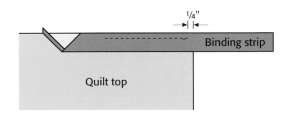

3. Fold the long strip in half lengthwise, with wrong sides together, and press. Cut one end at a 45° angle, turn under ¼", and press. You will start sewing with this end. If you haven't already trimmed the backing and batting even with the quilt top, do so now. Also, if you want to add a hanging sleeve (see next section), add it before you bind the edges.

4. Use a precise ¼" seam to attach your binding. Start along one side (not at a corner). Keep raw edges even as you stitch the binding to the quilt top. When you come to the first corner, stop stitching ¼" from the corner and backstitch.

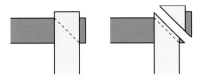

5. Fold the binding up and then back down onto itself, squaring the corner. Turn the quilt 90° under the presser foot. Begin sewing again at the very edge of the quilt top, backstitching to secure the stitches. Continue around the quilt.

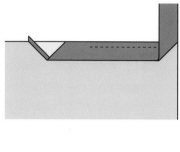

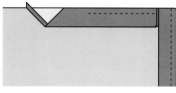

6. When you reach the beginning point, overlap your original stitches by 1" to 2". Cut away excess binding and trim the end on the diagonal. Tuck the raw edges inside the binding.

7. Fold the binding over the raw edges of all layers. Use a hand or machine blind stitch to sew the binding to the backing.

Making a Hanging Sleeve

A hanging sleeve is a must for any quilt that will be displayed on a wall. Other methods of hanging put a great deal of stress on the fabrics and will shorten the life of your beautiful quilt considerably. Making a sleeve is easy, and—after all the labor you've invested in your quilt—why wouldn't you make one?

1. Either use fabrics left over from your quilt or use a length of muslin. Cut a strip 8" wide, about 1" shorter than the width of the top edge of your quilt. Double-fold the short ends (fold under ½", and then ½" again). Stitch.

2. Fold the strip in half lengthwise, wrong sides together, and baste the raw edges to the top edge of the back of the quilt. When you add the binding, the edges of the sleeve will be secured and permanently attached.

3. After your binding is complete, finish the hanging sleeve by blindstitching the bottom into position, as shown.

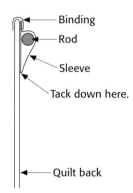

4. Don't forget to sign and date your quilt.

The Projects

Love and Friendship

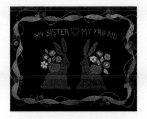 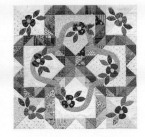

Young at Heart

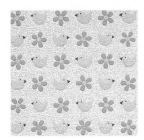 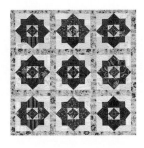

Hearth and Home

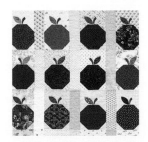 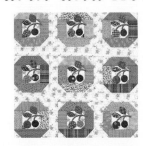 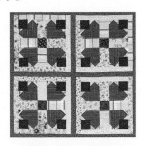

Memorable Moments

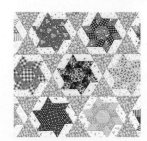 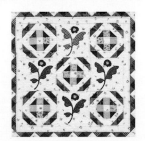

Holidays

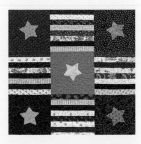 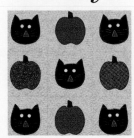 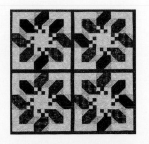

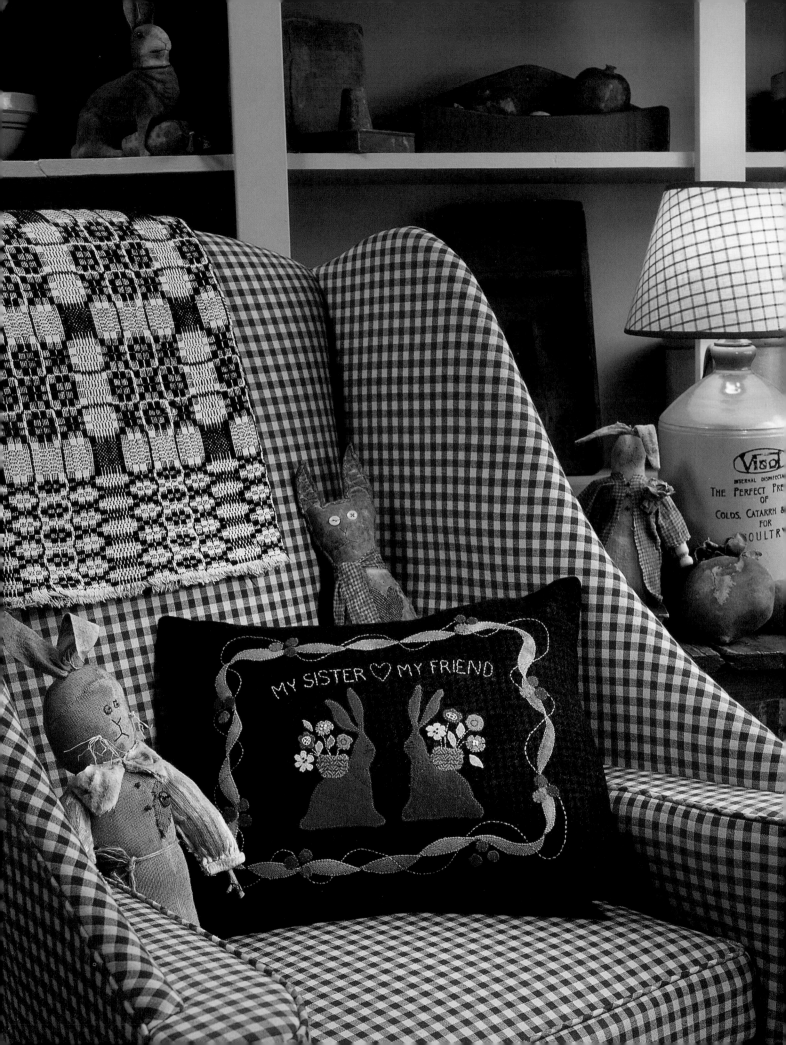

My Sister, My Friend

This pillow was a gift for my sister Teri. We've shared many wonderful experiences while designing quilts—lots of phone calls and, lately, emails. Sometimes we want to talk about a new project we're working on, and other times we just need encouragement. Recently I sent Teri an email saying that I had just spent two days turning a perfectly lovely quilt into the worst-looking thing I'd ever seen. (Luckily I can rip out seams really fast.) Teri is a great cheerleader, and I love the way she is always supportive and lots of fun; but most of all, I love her as my sister.

One way that women share their love and friendship with each other is by giving handmade gifts. Pillows are a great gift idea because they are fast and easy to make, and they don't require a lot of yardage.—Barbara

Materials

Yardage is based on 54"- or 60"-wide wool and 42"-wide muslin. We assume that you will have at least 40" of usable width after prewashing the muslin and trimming the selvages.

- ⅝ yard of muslin for pillow form
- ½ yard of black *felted* wool for pillow (see "Felted Wool" at right)
- Assorted scraps of *felted* wool in rust, pink, red, green, gold, blue, and tan for appliqué
- Embroidery floss in colors to match each wool scrap, plus black, brown, and gold
- Polyester fiberfill
- Embroidery hoop and needles
- Freezer paper
- Fabric glue

FELTED WOOL

Felted wool can be purchased in quilt stores, or you can felt your own. If you plan to felt your own, you will need to purchase a little extra yardage—1 yard of 100% black wool. To felt the wool, hand wash in extremely hot water or simmer on the stove. Rinse in cold water, using extreme care to avoid burns when transferring the wool from hot water to cold. Dry in the dryer on the hot cycle. Repeat a couple of times, until the wool is felted.

Cutting

From the felted black wool, cut:
1 piece, 15½" x 18½"
2 pieces, 13" x 15½"

From the muslin, cut:
2 pieces, 17" x 20"

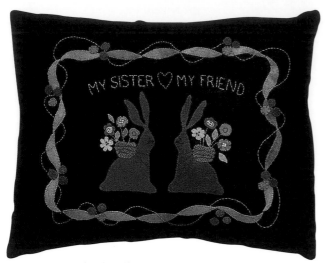

Finished Pillow Size: 17½" x 14½"

Appliquéing the Pillow

1. Trace all of the bunny, basket, flower, leaf, and vine patterns on pages 20–21 onto the dull side of the freezer paper. Trace 24 of berry pattern 37. Number the pieces, to keep things organized, and cut out the shapes about ¼" outside of the drawn lines.

2. With the shiny side of the freezer paper down, iron each pattern piece onto the color of wool you have chosen for that piece. Cut out the general shape along the edge of the freezer paper. Now carefully cut out the shape exactly. Keep the freezer paper attached to remind you of each shape's number and also to keep the pieces stable.

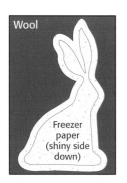

Wool

Freezer paper (shiny side down)

3. Appliqué the bunny pieces first. Using the placement diagrams on pages 20–21 as a guide, position the bunnies onto the 15½" x 18½" black pillow front. Remove the freezer paper and use several tiny drops of fabric glue to position and hold the pieces; let the glue dry. Using an embroidery hoop, blanket stitch around the shapes with two strands of matching embroidery floss. Refer to "Embroidery Stitches" on page 10 for an example of the blanket stitch.

4. Using the same technique as in step 3, appliqué the vine pieces next. Follow the numbers on the placement diagrams for positioning. The vine border should be placed approximately 3½" from the raw edges of the pillow front. Now appliqué the baskets, flowers, leaves, and berries.

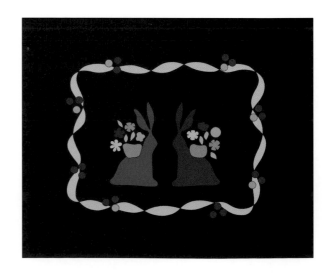

Embroidery

Refer to "Embroidery Stitches" for examples of the French knot and backstitch.

1. Use a white marking pencil to transfer the embroidery details to the pillow front. Embroider French knots for the bunny eyes with two strands of black embroidery floss. Backstitch the nose and whiskers with one strand of black floss. Use two strands of brown floss to backstitch the band around each bunny's neck and the lines on the baskets.

2. Embroider the flower details with a backstitch and/or French knots using two strands of black or other colors of embroidery floss. Use green floss to backstitch the stems. Backstitch the vine and the phrase with three strands of gold embroidery floss.

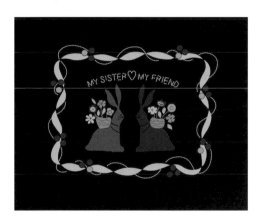

Completing the Pillow

1. Hem one long edge of each 13" x 15½" black pillow back with a ½" double-rolled hem. (Fold under ½", and then fold under ½" again. Press to hold, and stitch in place.)

Make 2.

2. Place the pillow-back pieces, with the hems at the center, over the pillow front with right sides together and raw edges matching. The back pieces will overlap at the center. Sew around the perimeter of the pillow using a ½" seam allowance, pivoting at the corners. Trim the corners and turn the pillow right side out.

Trim corners.

3. Place the two muslin pieces right sides together. Stitch around the perimeter using a ½" seam allowance, leaving a 6" opening for turning inside out. Note that the pillow form will be 1" larger than the pillow so that the pillow cover will not sag.

Leave 6" opening for turning.

4. Turn the pillow form right side out and stuff with polyester fiberfill. Whipstitch the opening shut. Carefully insert the pillow form into the cover.

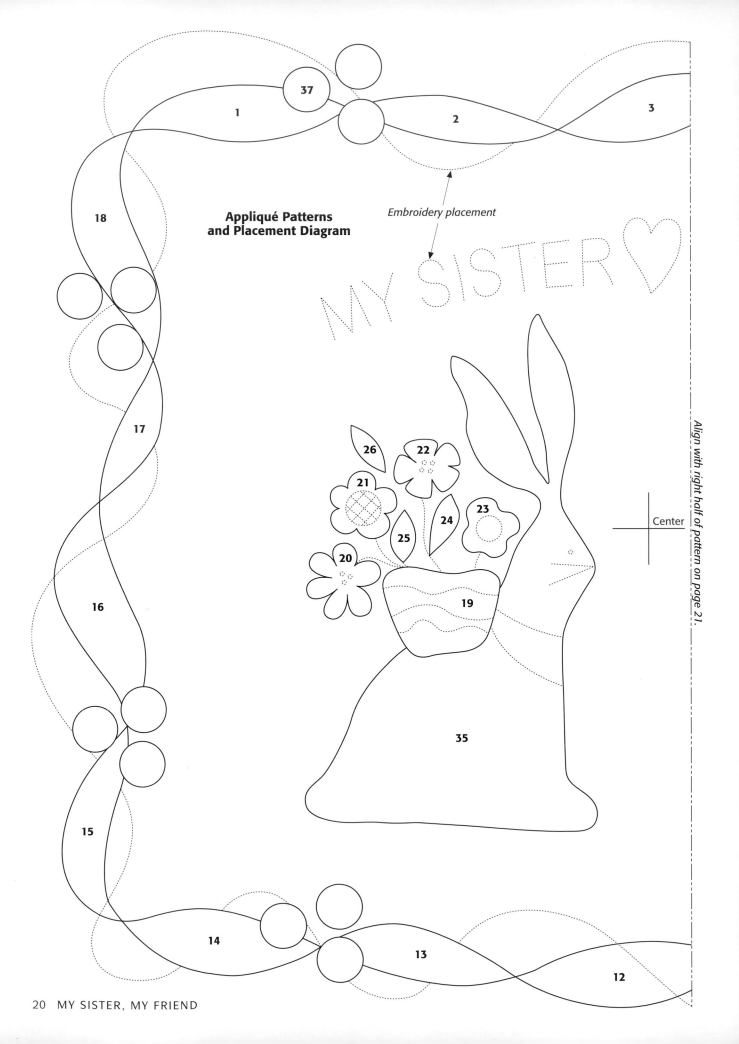

Appliqué Patterns and Placement Diagram

Embroidery placement

MY SISTER ♡

Align with right half of pattern on page 21.

Center

1

37

2

3

18

17

16

15

26

22

21

25

24

23

20

19

35

14

13

12

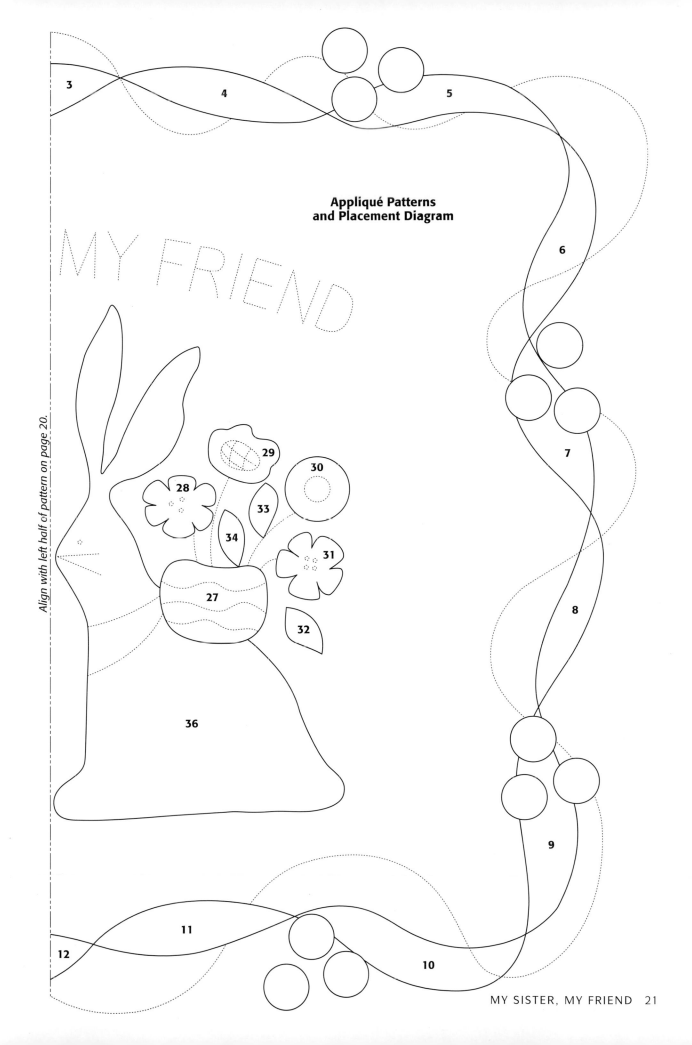

Appliqué Patterns
and Placement Diagram

MY FRIEND

Align with left half of pattern on page 20.

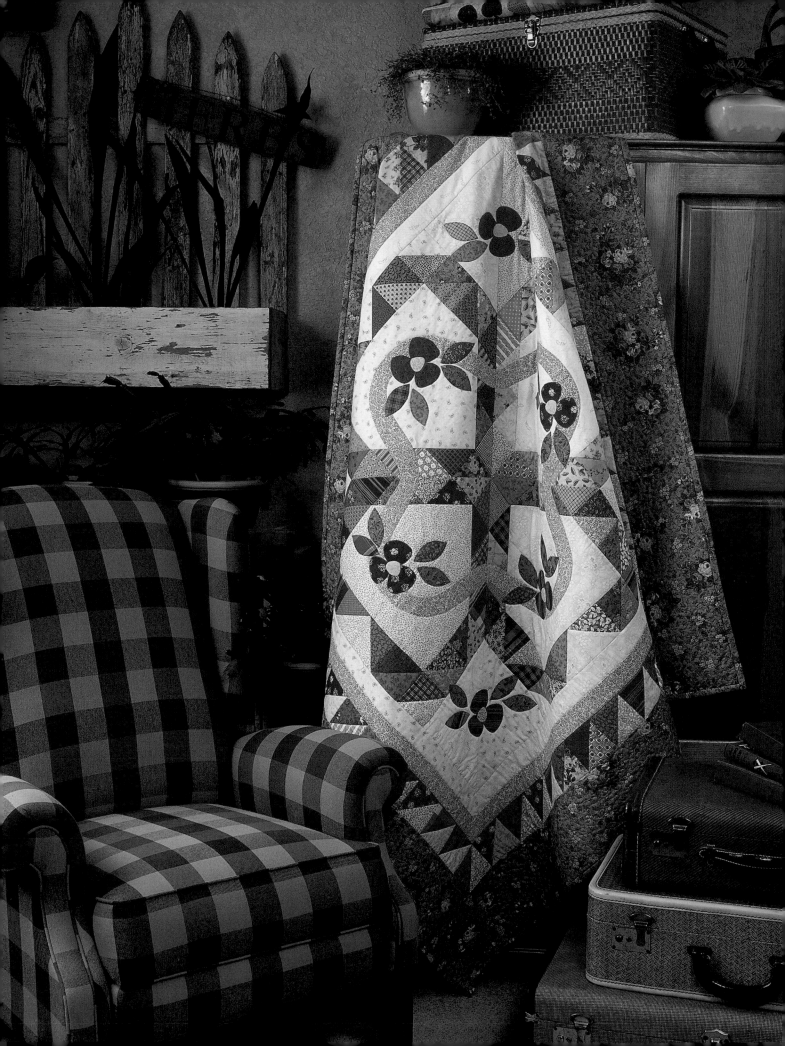

Wreath of Hearts

I designed this scrap heart quilt for my niece's bridal shower. It's exciting to watch the next generation of women in our family fall in love and begin their lives. Who knows where life will take them? One thing is certain, however—they will always be surrounded by the love of their mother, sisters, aunts, cousins, and friends.

Like many of you, I am completely addicted to fabric shopping. I get a secret little thrill from pulling those bolts off the shelf and arranging them in nice color combinations against the cutting counter. I love all of the colors, the prints, the textures, and the feel of the fabric. It's hard to walk out of a quilt store without an armload of purchases—especially when you have an enthusiastic sister or friend with you who is overbuying also. One of the reasons scrap quilting is so wonderful is that you can buy a single fat quarter of every print, and you don't feel like you've blown your budget.—Barbara

Materials

Yardage is based on 42"-wide fabric. We assume that you'll have at least 40" of usable width after prewashing the fabric and trimming the selvages.

- 1¾ yards of blue floral print for outer border and binding
- 1½ yards *total* of assorted off-white fabrics for blocks and first border
- ⅞ yard of light green print for vine and second border
- ⅞ yard of assorted pink fabrics for blocks, appliqué, and pieced border
- ¾ yard of assorted yellow fabrics for blocks, appliqué, and pieced border
- ⅝ yard of assorted green fabrics for blocks and appliqué
- ⅜ yard of assorted blue fabrics for blocks
- 4 yards of backing fabric
- 66" x 66" piece of batting
- 2⅜ yards of fusible web
- Template plastic

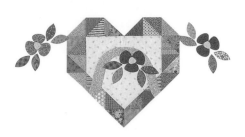

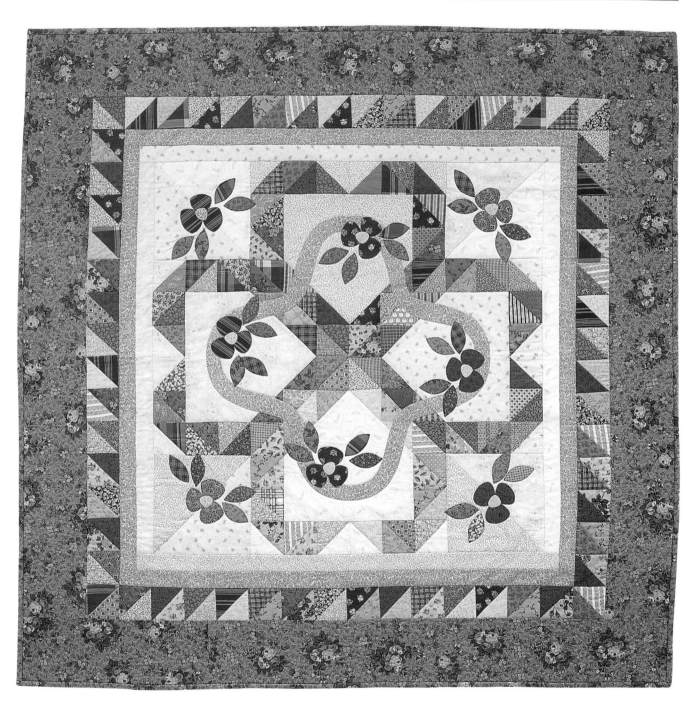

Finished Quilt Size: 60½" x 60½"

Cutting

Patterns for the vine, flower, flower center, and leaves are on pages 30–31.

From the assorted off-white fabrics, cut:

4 squares, 12½" x 12½"

4 squares, 9⅞" x 9⅞"; cut once diagonally to yield 8 triangles

8 squares, 3⅞" x 3⅞"; cut once diagonally to yield 16 triangles

2 strips, 2" x 36½"

2 strips, 2" x 39½"

From the assorted pink fabrics, cut:

43 squares, 3⅞" x 3⅞"; cut 13 squares once diagonally to yield 26 triangles

8 flowers

From the assorted blue fabrics, cut:

13 squares, 3⅞" x 3⅞"; cut once diagonally to yield 26 triangles

From the assorted green fabrics, cut:

13 squares, 3⅞" x 3⅞"; cut once diagonally to yield 26 triangles

8 of each leaf pattern

From the assorted yellow fabrics, cut:

43 squares, 3⅞" x 3⅞"; cut 13 squares once diagonally to yield 26 triangles

8 flower centers

From the light green print, cut:

5 strips, 2" x width of fabric

4 vine pieces

4 vine pieces reversed

From the blue floral print, cut:

6 strips, 6½" x width of fabric

7 binding strips, 2½" x width of fabric

Making the Blocks

1. Trace the trimming template pattern on page 31 onto template plastic and cut out along the lines. Align the template with one corner of a 12½" off-white square. Cut along the diagonal edge and discard this triangle. Repeat with an adjacent corner as shown.

Make 4.

2. Join five pink triangles as shown. Press the seam allowances in one direction. Repeat with five more pink triangles to make a total of two sections for the diagonal sides of the heart.

Make 2.

3. Join three pink triangles, as shown, for the left side of the heart. Repeat in reverse, as shown, for the right side of the heart. Press the seam allowances toward the single triangle.

4. Join two pink triangles, as shown, for the bottom point of the heart. Press this seam allowance open to reduce bulk when the four hearts are sewn together.

5. Join eight pink triangles and four 3⅞" off-white triangles. Follow the placement on the illustration carefully. Press the seam allowances in one direction. This will be the top of the heart.

6. Sew the side pieces from step 3 to the sides of one off-white heart center. Sew the top section to the top of the heart. Press the seam allowances toward the pieced strips.

7. Attach the diagonal sides from step 2 next. Sew the bottom point to the heart last. Press the seam allowances toward the pieced strips.

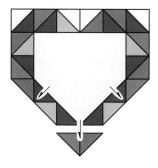

8. Sew two of the 9⅞" off-white triangles to the sides of the pink heart as shown. Press the seam allowances toward the triangles.

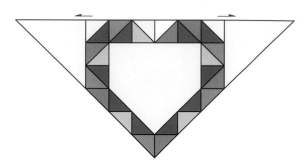

9. Repeat steps 2–8 with each set of 26 blue, green, and yellow 3⅞" triangles to make the other three heart sections.

Assembling the Quilt Top

1. Join the pink heart section to the green heart section and join the blue heart section to the yellow heart section as shown. Press these seam allowances open to reduce bulk when the four hearts are sewn together.

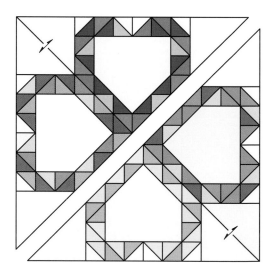

2. Sew the two triangle sections together to form the quilt center. Press this seam allowance open as well.

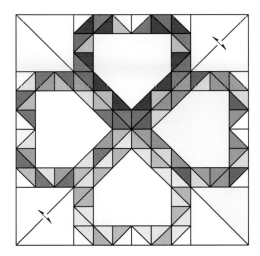

3. Referring to "Using Fusible Web" on page 9, prepare the green vine pieces, pink flowers, yellow centers, and green leaves for appliqué. Position the green vine pieces first, overlapping the ends at the seam lines and center of the hearts as shown. Iron to fuse in place. Machine blanket stitch the edges of the vine with matching thread. Position, fuse, and machine blanket stitch four pink flowers, four centers, and 16 leaves on top of the vine, as shown, using matching thread colors. Position, fuse, and machine blanket stitch four pink flowers, four centers, and 16 leaves on the four corners as well.

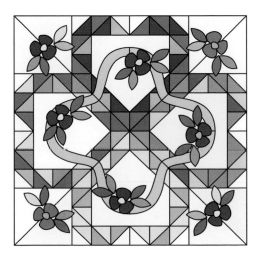

4. Sew the 36½" off-white border strips to the sides of the quilt, and then sew the 39½" off-white border strips to the top and bottom of the quilt. Press all seam allowances toward the borders.

5. Trim two of the 2"-wide green strips to 39½" long. Sew these to the sides of the quilt. Sew the remaining three green strips together end to end. From this long piece cut two border strips, 42½" long. Sew these to the top and bottom of the quilt. Press all seam allowances toward the green border.

6. Draw a diagonal line on the wrong side of the 3⅞" yellow squares. Place each yellow square with a 3⅞" pink square, right sides together, and sew ¼" from each side of the diagonal line. Cut on the line and press the seam allowances toward the pink fabric.

Make 60.

7. Join 14 triangle squares as shown to form one side border. Repeat with 14 more triangle squares to make a second side border. Press the seam allowances toward the yellow triangles.

Make 2.

8. Join 16 triangle squares as shown to form the top border. Note that the triangle square on one end is turned a different direction. Repeat with 16 more triangle squares to make the bottom border. Press the seam allowances toward the yellow triangles.

Make 2.

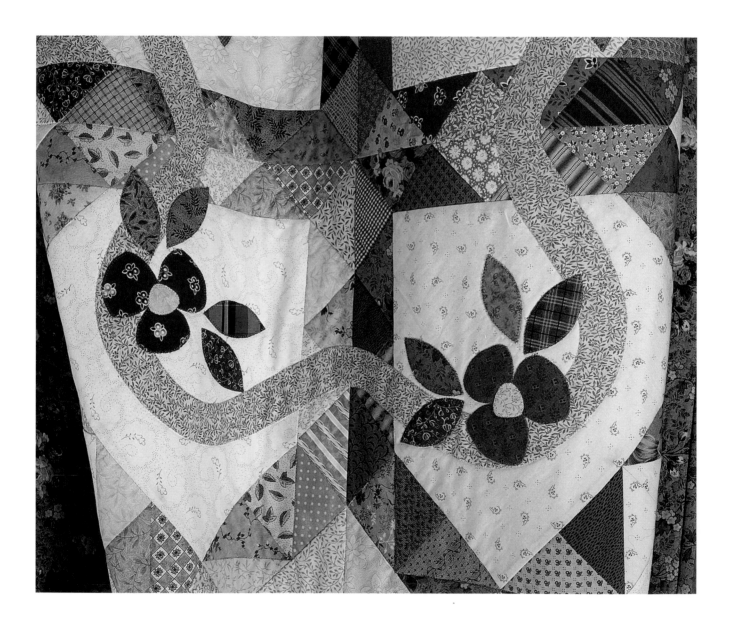

9. Sew the side border units to the quilt with the pink triangles next to the green border. Sew the top and bottom border units to the quilt, again placing the pink triangles next to the green border. Press all seam allowances toward the green border.

10. Sew three of the 6½"-wide blue floral strips together, end to end, to create one long piece. Repeat with the remaining three strips. From *each* long piece cut one border strip 48½" long and one border strip 60½" long. Sew the two 48½" strips to the sides of the quilt, and then sew the 60½" strips to the top and bottom of the quilt. Press all seam allowances toward the blue border.

Finishing

Refer to "Quilting" on page 12 and "Binding Your Quilt" on page 13 for more detailed instructions on finishing techniques, if needed.

1. Piece the quilt backing so that it is 4" to 6" larger than the quilt top.

2. Layer the quilt top with batting and backing, and baste the layers together.

3. Quilt as desired and bind using your favorite method.

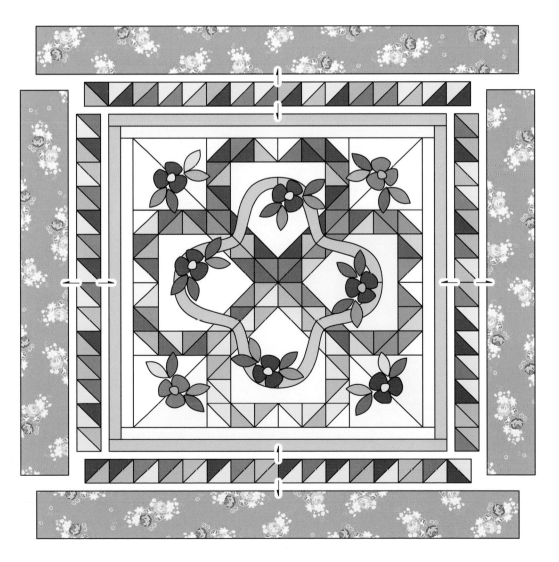

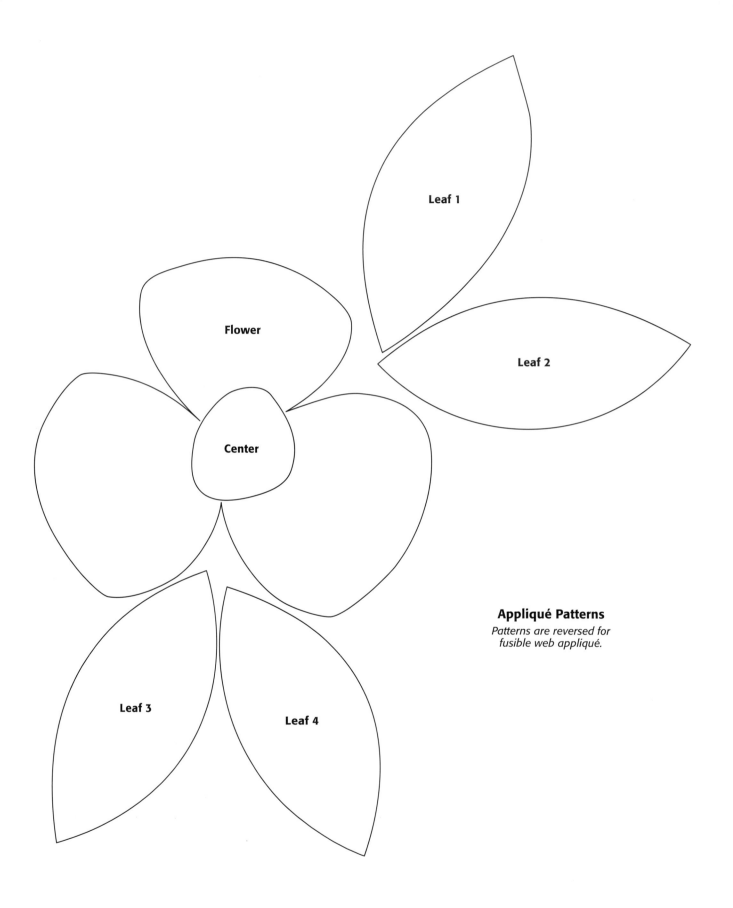

Appliqué Patterns

Patterns are reversed for fusible web appliqué.

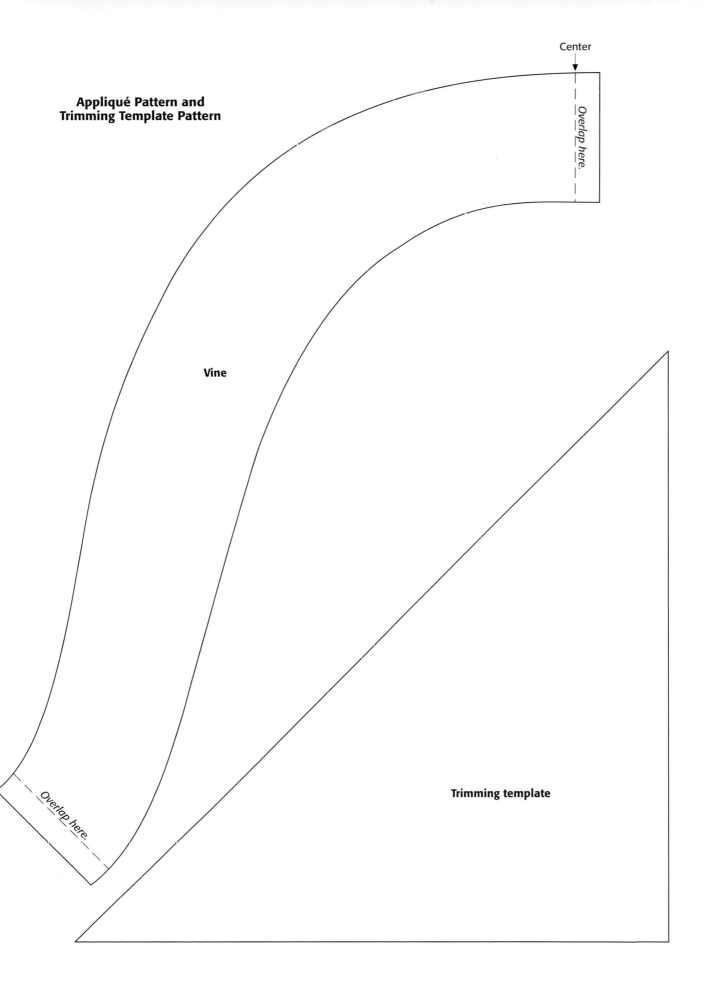

Appliqué Pattern and Trimming Template Pattern

Center

Overlap here.

Vine

Overlap here.

Trimming template

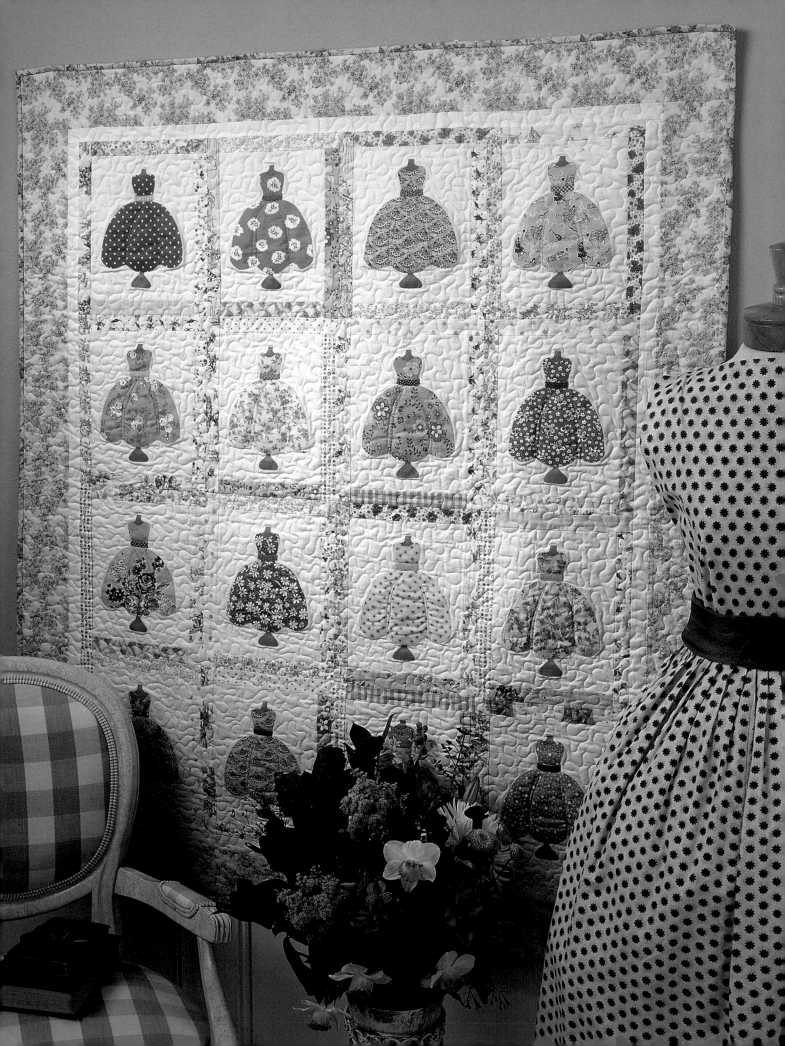

Pretty Dresses

What girl, young or old, doesn't love a pretty dress? These fancy little dresses are reminiscent of the days when teenage girls wanted to look pretty and frilly. I had a great time picking out the fabrics for the dresses, and the large shapes are easy to appliqué. Keep your block border prints very delicate so that they don't overpower the dresses.

I'll never forget the formal gown I wore to my high school homecoming dance when I was 16 years old. I selected a complicated dress pattern and a slippery rayon fabric and was soon overwhelmed by the sewing project. The day before the dance, I cried as I showed the incomplete dress to my mother, who happened to be sick in bed at the time. The next day, I came home from school to discover the finished dress hanging in my bedroom. Aren't mothers grand?—Teri

Materials

Yardage is based on 42"-wide fabric. We assume that you'll have at least 40" of usable width after prewashing the fabric and trimming the selvages.

- 2½ yards of white fabric for blocks, inner border, and dress linings*
- 1 yard of light print fabric for outer border
- ½ yard of light brown fabric for dress forms
- ¼ yard *each* of 4 or more different print fabrics for dresses (I recommend using more)
- ⅛ yard *each* of 12 or more different delicate fabrics for block borders
- 3½ yards of backing fabric
- ⅝ yard of binding fabric
- 54" x 62" piece of batting
- 2 yards of fusible web
- "Invisible" monofilament thread
- Water-soluble fabric marker

** Every pretty dress needs a good slip. If your dress fabrics are pastel like mine, line them with solid white fabric to prevent the dress form from showing through. If your dress fabrics are dark, you will not need dress linings.*

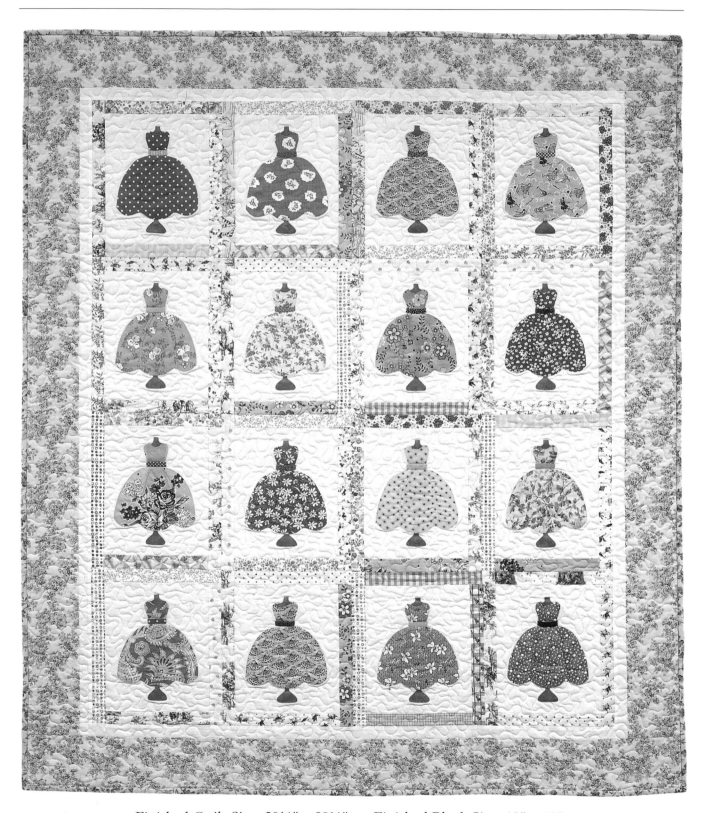

Finished Quilt Size: 50½" x 58½" • Finished Block Size: 10" x 12"

Cutting

Patterns for the dress form, dress, and waistband are on pages 38–39.

From the print fabrics for dresses, cut:

16 dresses

16 waistbands

From the light brown fabric, cut:

16 dress forms

From the white fabric, cut:

4 strips, 10½" x width of fabric; crosscut into
 16 rectangles, 8½" x 10½"

5 strips, 1½" x width of fabric

16 dress linings (Use the dress pattern and see
 step 1 of "Making the Blocks" below.)

**From the delicate fabrics for block borders,
cut an assortment of:**

16 strips, 1½" x 8½"

16 strips, 1½" x 9½"

16 strips, 1½" x 11½"

16 strips, 1½" x 12½"

From the light print fabric, cut:

6 strips, 4½" x width of fabric

From the binding fabric cut:

6 strips, 2½" x width of fabric

Making the Blocks

1. Referring to "Using Fusible Web" on page 9,
 prepare dresses, dress forms, waistbands, and
 dress linings for appliqué. For the dress
 linings, trace the dress appliqué pattern, but
 cut just inside the line so that the white
 linings are ¹⁄₁₆" smaller than the dresses.

2. To help position the dresses in the center of
 the white rectangles, draw a vertical place-
 ment line down the center of the block with a
 water-soluble fabric marker.

3. Center a dress form, dress lining, dress, and
 waistband on each white rectangle. Iron to
 fuse in place. Appliqué the edges of the pieces
 using a small machine blanket stitch and
 "invisible" monofilament thread.

4. Sew a 1½" x 8½" block border strip to the
 bottom of a dress block. Sew a 1½" x 11½"
 strip from a different fabric to the right side
 of the dress block. Sew a 1½" x 9½" strip
 from yet another fabric to the top of the dress
 block. Sew a 1½" x 12½" strip from a final
 different fabric to the left side of the dress
 block. Press all seam allowances toward the
 border strips as you add them. Repeat this
 step to make a total of 16 dress blocks using
 four different fabrics for each block.

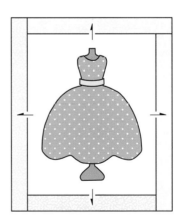

Assembling the Quilt Top

1. Arrange the dress blocks into four rows of four blocks each. Move the blocks around until the brightest and busiest prints are evenly distributed across the quilt. Sew the blocks together into rows, pressing the seam allowances in the opposite direction from row to row. Sew the rows together to make the quilt center and press the seam allowances in one direction.

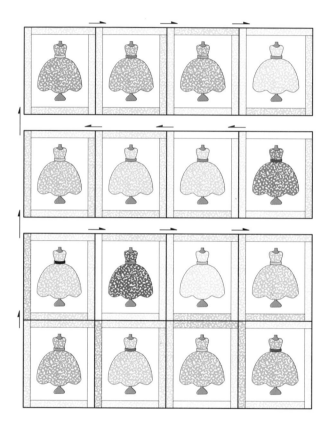

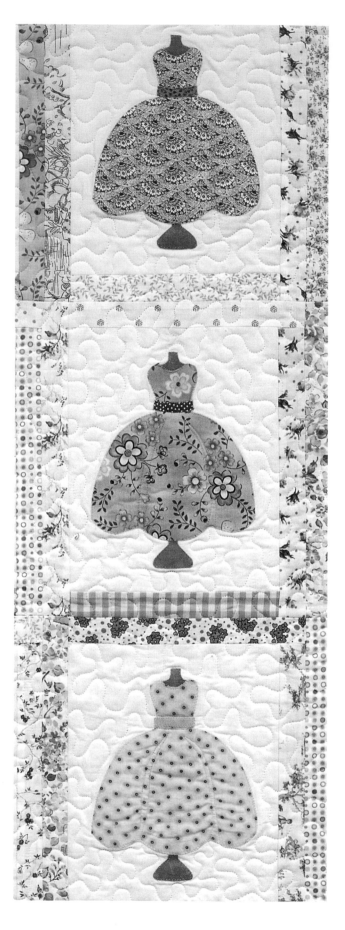

2. Join the five 1½"-wide white strips, end to end, to make one long piece. From this piece cut two border strips 48½" long and two border strips 42½" long. Sew the 48½" strips to the sides of the quilt, and then sew the 42½" strips to the top and bottom of the quilt. Press all seam allowances toward the white border.

3. Join three of the 4½"-wide light print strips, end to end, to make one long piece. Repeat with the remaining three strips. From *each* of these pieces cut two border strips, 50½" long. Sew two of these strips to the sides of the quilt, and then sew the remaining two strips to the top and bottom of the quilt. Press all seam allowances toward the light print border.

Finishing

Refer to "Quilting" on page 12 and "Binding Your Quilt" on page 13 for more detailed instructions on finishing techniques, if needed.

1. Piece the quilt backing so that it is 4" to 6" larger than the quilt top.

2. Layer the quilt top with batting and backing, and baste the layers together.

3. Quilt as desired and bind using your favorite method.

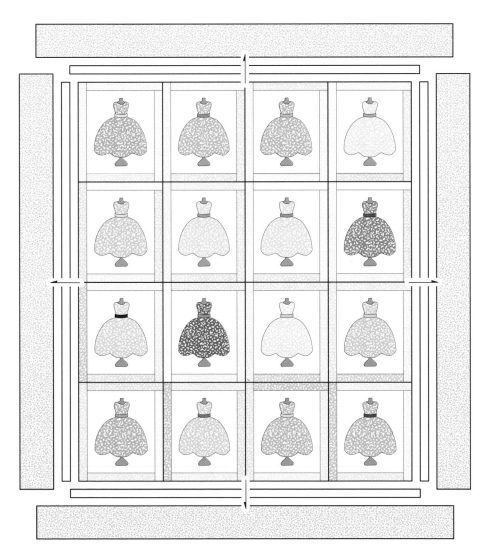

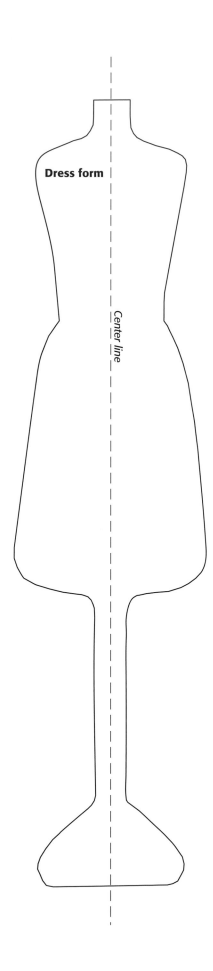

Dress form

Center line

Appliqué Pattern

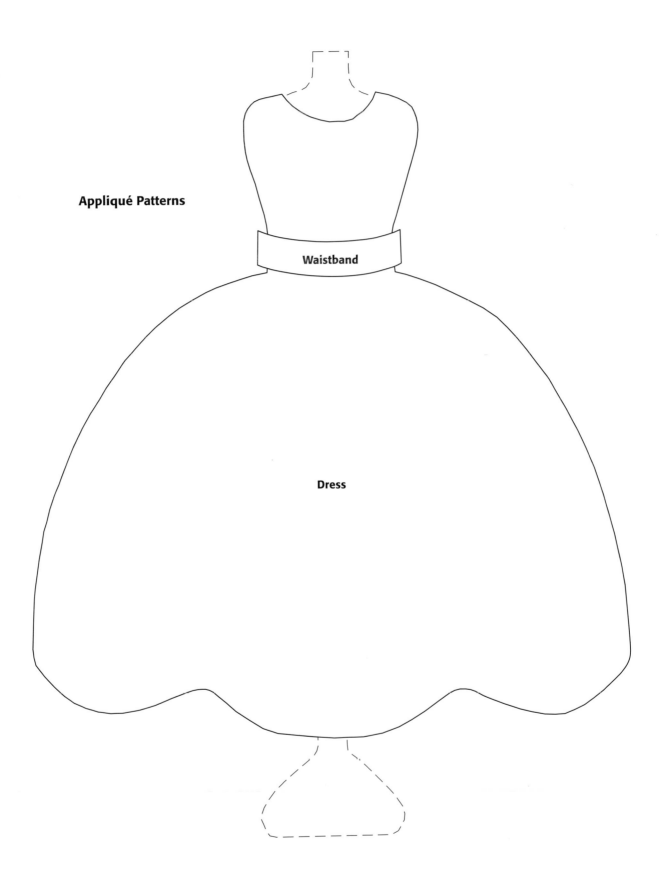

Appliqué Patterns

Waistband

Dress

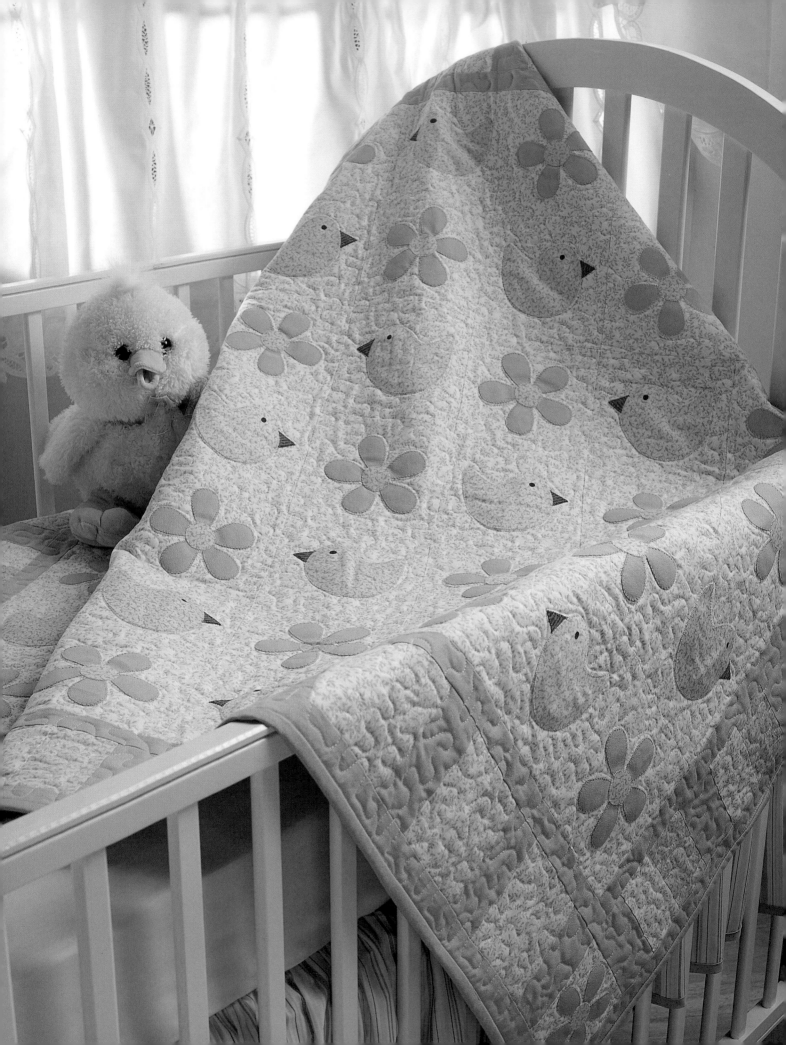

Duckies and Daisies

This darling baby quilt is the perfect gift for a new little princess. It's big enough to spread on the ground or be dragged around by a toddler, and so easy to make, you won't mind the abuse.

After my first baby, Kelsi, was born, a friend showed up at my door with a beautiful pink baby quilt that she had hand appliquéd and quilted for me. I was very touched to receive such a precious gift. Fourteen years later, that quilt is still cherished in our household; now seven-year-old Maia sleeps with it every night. I've lost touch with that friend over the years, but I wish I could tell her how much her quilt has been cuddled and loved.—Teri

Materials

Yardage is based on 42"-wide fabric. We assume that you'll have at least 40" of usable width after prewashing the fabric and trimming the selvages.

- 2¼ yards of light fabric for blocks and borders
- 2 yards of lavender fabric for appliqué, borders, and binding
- ¾ yard of yellow fabric for appliqué and borders
- ¾ yard of solid white fabric for linings
- ⅛ yard of orange fabric for appliqué
- Scrap of solid black fabric for eyes (optional)
- 3⅝ yards of backing fabric
- 58" x 58" piece of batting
- 4½ yards of fusible web
- Black permanent fabric marker

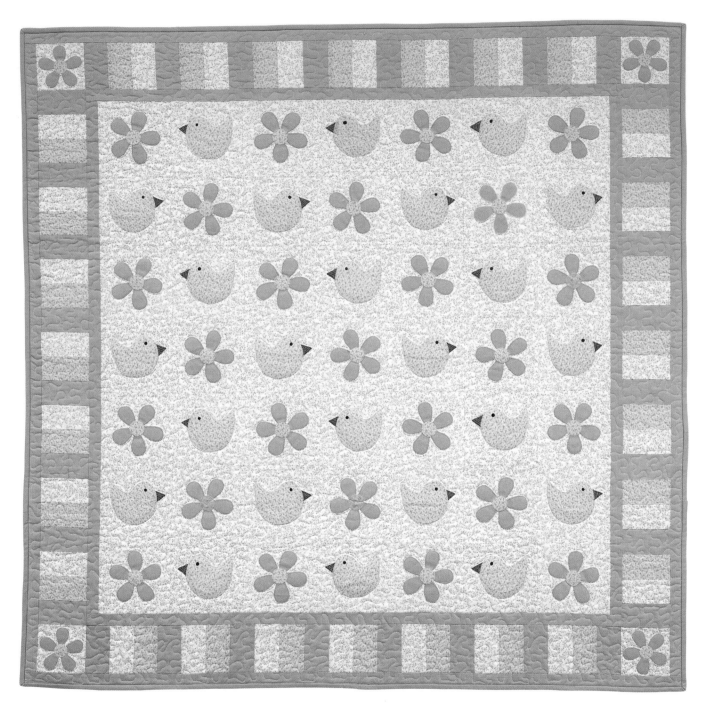

Finished Quilt Size: 54½" x 54½" • Finished Block Size: 6" x 6"

Cutting

Patterns for the duckies, daisies, daisy centers, beak, and eye are on pages 46–47.

From the lavender fabric, cut:

2 strips, 4½" x width of fabric; crosscut into
 32 rectangles, 2½" x 4½"

10 strips, 1½" x width of fabric

6 binding strips, 2½" x width of fabric

25 large daisies

4 small daisies

From the yellow fabric, cut:

2 strips, 4½" x width of fabric; crosscut into
 28 rectangles, 2½" x 4½"

12 left-facing duckies

12 right-facing duckies

25 large daisy centers

4 small daisy centers

From the orange fabric, cut:

24 beaks

From the solid white fabric, cut:

Cut these pieces inside the drawn line so that they will be ¹/₁₆" smaller than the yellow pieces.

12 left-facing duckies

12 right-facing duckies

25 large daisy centers

4 small daisy centers

From the light fabric, cut:

9 strips, 6½" x width of fabric; crosscut into
 49 squares, 6½" x 6½"

2 strips, 4½" x width of fabric; crosscut into
 28 rectangles, 2½" x 4½"

4 squares, 4½" x 4½"

Making the Blocks

1. Referring to "Using Fusible Web" on page 9, prepare the large daisies, small daisies, left-facing duckies, right-facing duckies, linings (the duckies and daisy centers need to be lined with solid white fabric to prevent see-through), and beaks for appliqué. If you plan to appliqué the duckies' eyes, prepare 24 of those using the scrap of solid black fabric.

2. Draw eyes onto the duckies using a black permanent fabric marker. Or, if you prefer, wait until step 4 and appliqué the eyes.

3. Position 12 left-facing duckies and 12 right-facing duckies on 24 of the 6½" light squares. Place the white lining pieces underneath the yellow duckies. The duckies need to be positioned exactly the same on each block, which can be challenging due to their rounded bottoms. Trace the placement diagram on page 46 (including the square) onto plain white paper. Then trace it *reversed* onto a second sheet of plain white paper. You now have two placement diagrams, one facing right, and one facing left. Lay the 6½" light squares on top of the placement diagrams when positioning the appliqué. You will be able to see the lines through the fabric to position each ducky exactly, with lining, ensuring that every block is identical.

4. Slip a beak into position under both fabrics. If you are using appliqué eyes, place an eye on the ducky. Iron to fuse in place.

5. Position the 25 large daisies on the remaining 6½" light squares. Unlike the duckies, the daisies should not be positioned identically. Center them on the block, but do not be concerned about the angle of the petals. This haphazard placement gives movement to the quilt. Place the white lining pieces underneath the yellow daisy centers. Iron to fuse in place.

6. Position the four small daisies on the 4½" light squares. Place the white lining pieces underneath the yellow daisy centers. Iron to fuse in place.

7. Machine blanket stitch the edges of the pieces using matching thread colors.

Assembling the Quilt Top

1. Lay out the ducky blocks and the 6½" daisy blocks in seven rows of seven blocks each as shown. Make sure your duckies are facing the correct direction. Sew the blocks together into rows, pressing the seam allowances in the opposite direction from row to row. Sew the rows together to make the quilt center, and press the seam allowances in one direction.

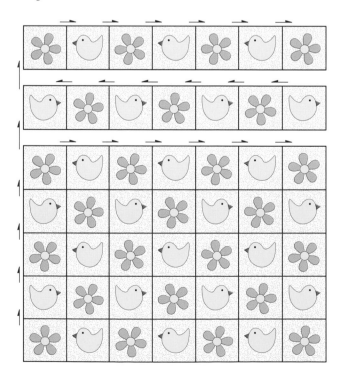

2. Sew five of the 1½" lavender strips together, end to end, to create one long piece. From this piece, cut two border strips 42½" long and two border strips 44½" long. Sew the two 42½" strips to the sides of the quilt, and then sew the 44½" strips to the top and bottom of the quilt. Press all seam allowances toward the border.

3. Sew one lavender, one yellow, and one light rectangle together as shown. Press the seam allowances in one direction. Repeat to make a total of 28 segments.

Make 28.

4. Sew seven of these units together as shown, and then sew a lavender rectangle to the end with the light rectangle. Press the seam allowances in one direction. Repeat until you have four of these striped borders, all identical.

Make 4.

5. Sew a 4½" daisy block to each end of two of the striped borders and press the seam allowances toward the lavender rectangles.

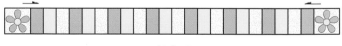

Make 2.

6. Sew the two striped borders without corner squares to the sides of the quilt. Make sure they are rotated properly as shown on page 45. Sew the two striped borders with corner squares to the top and bottom of the quilt, making sure they are rotated properly. Press all seam allowances toward the inner lavender border.

7. Sew the remaining five 1½" lavender strips and the piece left over from step 2 together, end to end, to create one long piece. From this piece, cut two border strips 52½" long and two border strips 54½" long. Sew the two 52½" strips to the sides of the quilt and then sew the 54½" strips to the top and bottom of the quilt. Press all seam allowances toward the outer lavender border.

Finishing

Refer to "Quilting" on page 12 and "Binding Your Quilt" on page 13 for more detailed instructions on finishing techniques, if needed.

1. Piece the quilt backing so that it is 4" to 6" larger than the quilt top.

2. Layer the quilt top with batting and backing, and baste the layers together.

3. Quilt as desired and bind using your favorite method.

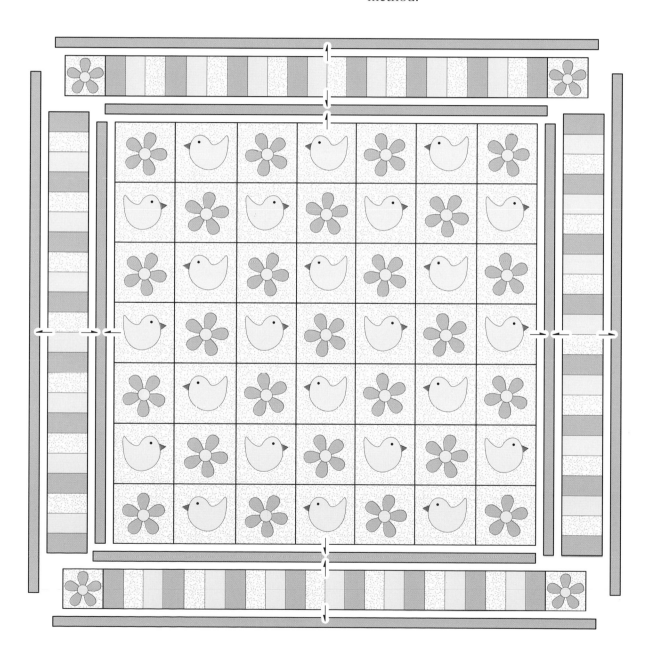

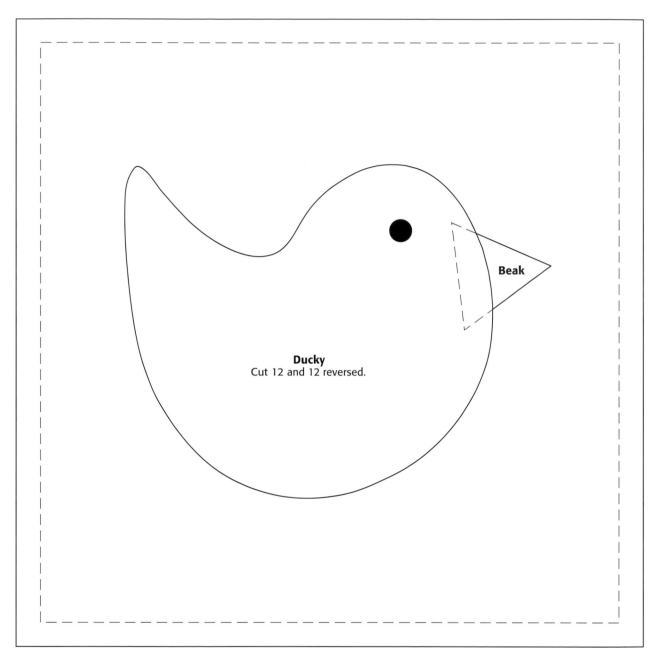

Ducky
Cut 12 and 12 reversed.

Beak

**Appliqué Patterns and
Placement Diagram**

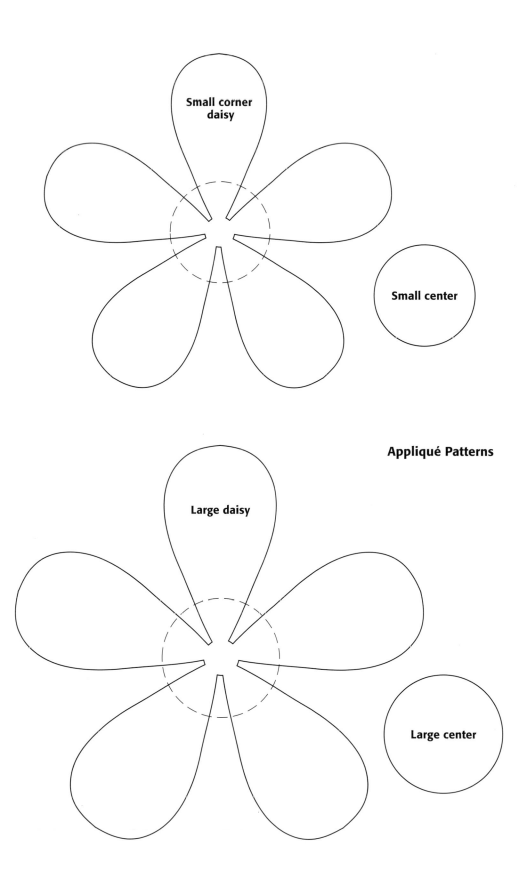

Small corner daisy

Small center

Appliqué Patterns

Large daisy

Large center

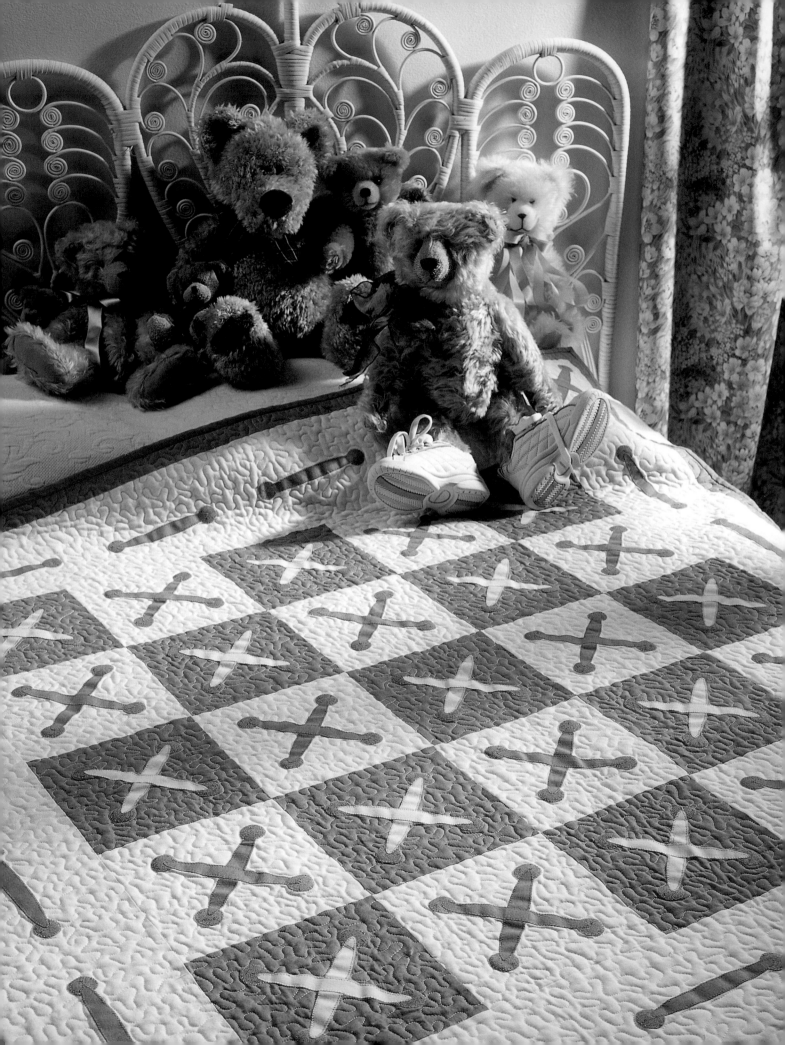

Pink Shoelaces

This quilt was designed on a whim, and I love the result—so simple, yet so adorable. It would also look great done in blue and white for a boy.

It was my mother who taught me how to tie my shoelaces, of course. As I grew up, I invented my own unusual way of doing it, without even realizing it. When I was a teenager, my mother saw what I was doing and laughed in surprise, "I think you're the only person in the world who ties her shoes that way, Teri." This was news to me! She sat me down and showed me the proper method all over again, both of us laughing as I struggled to tie a simple bow. Within a week, I was tying them oddly again. I guess I'm just one of those people who likes to do things her own way.—Teri

Materials

Yardage is based on 42"-wide fabric. We assume that you'll have at least 40" of usable width after prewashing the fabric and trimming the selvages.

- 2 yards of white fabric for blocks, appliqué, and border
- 1⅝ yards of pink fabric for blocks, appliqué, border, and binding
- ¼ yard of gray fabric for appliqué
- 3½ yards of backing fabric
- 54" x 54" piece of batting
- 1 yard of fusible web
- Water-soluble fabric marker

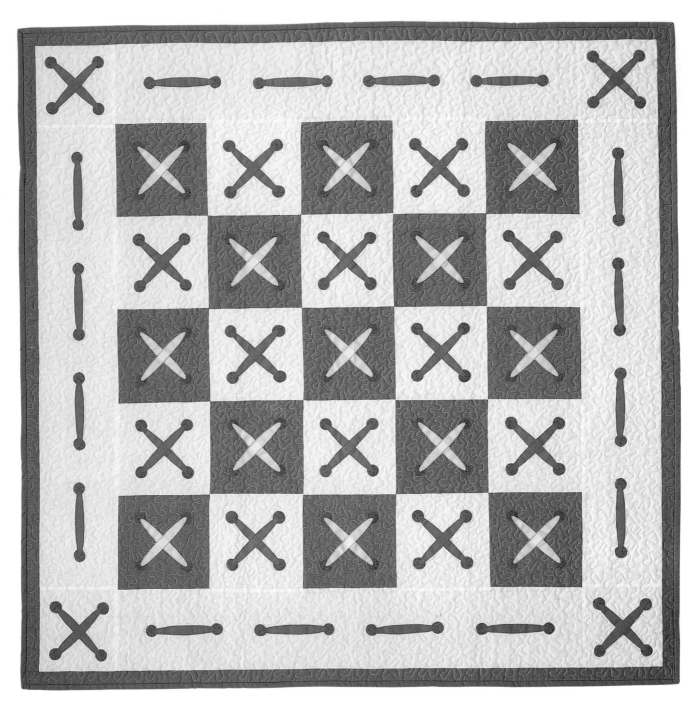

Finished Quilt Size: 49½" x 49½" • Finished Block Size: 7" x 7"

Cutting

Patterns for shoelaces and grommets are on page 53.

From the white fabric, cut:

3 strips, 7½" x width of fabric; crosscut into 12 squares, 7½" x 7½"

5 strips, 6½" x width of fabric; crosscut 1 strip into 4 squares, 6½" x 6½"

26 shoelaces

From the pink fabric, cut:

3 strips, 7½" x width of fabric; crosscut into 13 squares, 7½" x 7½"

5 strips, 1½" x width of fabric

6 binding strips, 2½" x width of fabric

48 shoelaces

From the gray fabric, cut:

148 grommets

Making the Blocks

1. Referring to "Using Fusible Web" on page 9, prepare the white shoelaces, pink shoelaces, and gray grommets for appliqué.

2. To help position your shoelaces, use a ruler and a water-soluble fabric marker to draw an X on all of the pink and white squares.

3. Position four gray grommets and two white shoelaces on a pink square. The shoelace going from the top left corner toward the bottom right corner should be on top of the other shoelace. Iron to fuse in place. Appliqué the edges with a machine blanket stitch. I used gray thread for the grommets and also for the white shoelaces to give a three-dimensional shadow effect. Repeat to make a total of 13 pink blocks.

Make 13.

4. Position four gray grommets and two pink shoelaces on a 7½" white square. The shoelace going from the top left corner toward the bottom right corner should be on top of the other shoelace. Iron to fuse in place. Appliqué the edges with a machine blanket stitch. For these blocks I used gray thread for the grommets and pink thread for the shoelaces. Repeat to make a total of 12 white blocks.

Make 12.

Assembling the Quilt Top

1. Arrange the pink and white shoelace blocks into five rows of five blocks each as shown. Place each block so that the shoelace going from the top left corner toward the bottom right corner is the overlapping shoelace.

2. Sew the blocks together into rows and press the seam allowances toward the pink blocks. Sew the rows together to form the quilt center, and press the seam allowances in one direction.

3. Repeat step 4 of "Making the Blocks" by appliquéing grommets and pink shoelaces onto the four 6½" white squares. (The blocks are smaller than the center blocks, but you should use the same shoelace pattern.)

4. Trim each of the four 6½"-wide white strips to 35½" long. Use a long ruler and water-soluble fabric marker to draw placement lines on the white strips as shown. First, draw a long horizontal center line down the length of the fabric, exactly 3¼" away from the fabric edges. Then draw short vertical lines. The first vertical line should be 2⅜" away from one short end of the fabric. Draw the next

vertical line 6" away from that, and the next line 2¼" away. Alternate between 6" and 2¼" spacing until you reach the end, where approximately 2⅜" should remain.

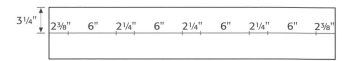

5. Position eight gray grommets and four pink shoelaces on each of the white borders. The shoelaces should be 2⅜" away from the short ends of the fabric and 2¼" away from each other. Iron to fuse in place. Appliqué the edges with a machine blanket stitch and matching gray and pink threads.

Make 4.

6. Sew two of these white border strips to the sides of the quilt and press the seam allowances toward the borders. Sew two of the 6½" white squares to the ends of each of the remaining white border strips. Press the seam allowances toward the border strips. Sew these borders to the top and bottom of the quilt, and press the seam allowances toward the border.

7. Sew the five 1½" pink strips together, end to end, to create one long piece. From this piece cut two border strips 47½" long and two border strips 49½" long. Sew the 47½" strips to the sides of the quilt, and then sew the 49½" strips to the top and bottom of the quilt. Press all seam allowances toward the border.

Finishing

Refer to "Quilting" on page 12 and "Binding Your Quilt" on page 13 for more detailed instructions on finishing techniques, if needed.

1. Piece the quilt backing so that it is 4" to 6" larger than the quilt top.

2. Layer the quilt top with batting and backing, and baste the layers together.

3. Quilt as desired and bind using your favorite method.

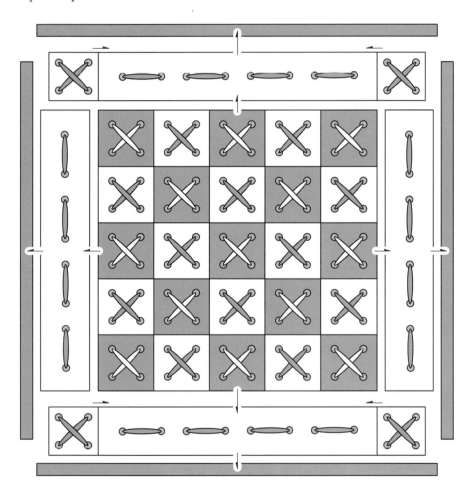

Appliqué Patterns

Shoelace

Grommet

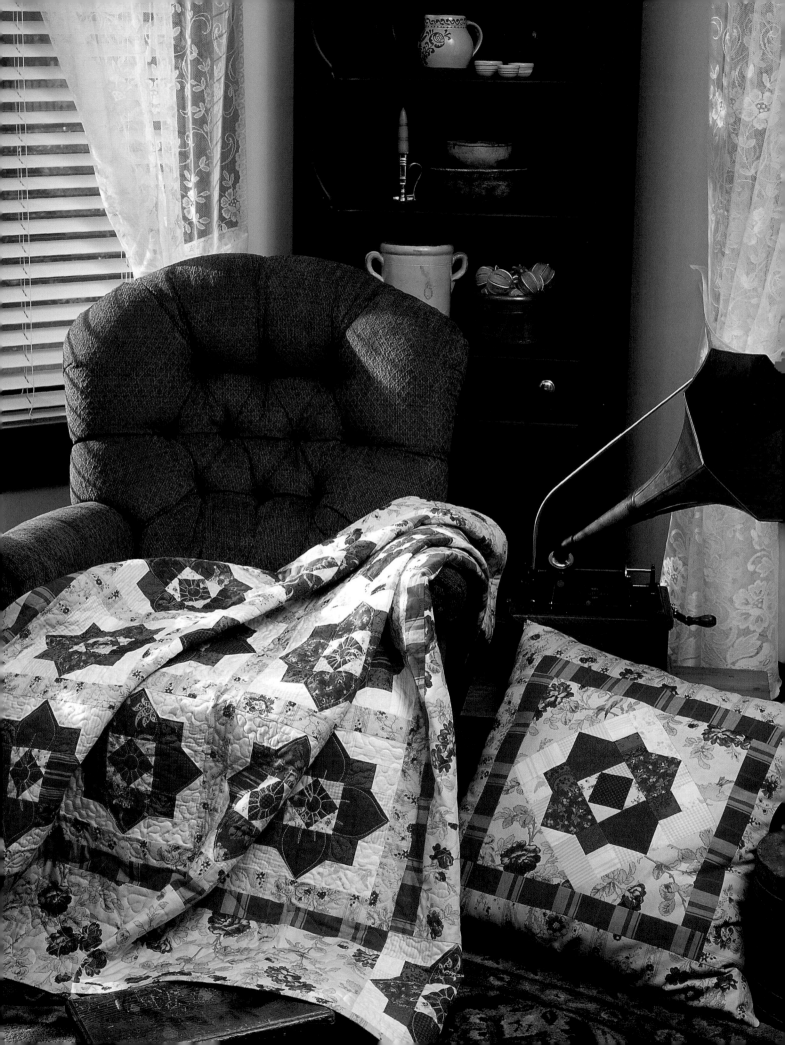

New Prairie Flower Quilt and Pillow

My teenage daughter Katie decorated her bedroom in a 1950s retro look. She painted each wall a different color—turquoise, flamingo, chartreuse, and purple. All I can say is that I must have been in a very good mood that day! The thing that drives me crazy is that she insists on sleeping with a ratty old throw quilt she found in her brother's bedroom. I thought if I made her a pretty quilt with an extra-soft backing and a matching pillow, and just left them in the vicinity of her room, they might find their way onto her bed. A mother can only hope.

It is so much fun to pass the joy of quilting on to the next generation. They are eager to learn, and a pillow is a perfect starter project. It's important that beginners have the success of a completed project right away, and a quilted pillow really fits the bill.—Barbara

Quilt Materials

Yardage is based on 42"-wide fabric. We assume that you'll have at least 40" of usable width after prewashing the fabric and trimming the selvages.

- 2¼ yards of turquoise print for sashing, outer border, and binding
- 1 yard of assorted red fabrics for blocks
- ⅜ yard of red plaid or stripe for inner border
- ⅜ yard of assorted yellow fabrics for blocks
- 1⅛ yards *total* of assorted off-white fabrics for blocks
- ⅛ yard *each* of 4 brown fabrics for blocks
- 3½ yards of backing fabric
- 57" x 68" piece of batting

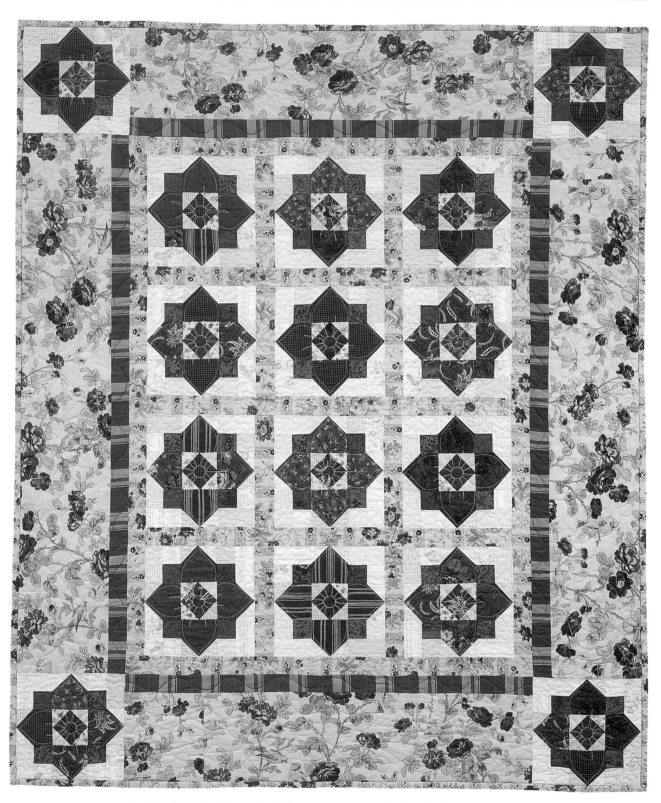

Finished Quilt Size: 51½" x 62" • Finished Block Size: 9" x 9"

Cutting

From *each* of the brown fabrics, cut:
1 strip, 2" x width of fabric

From the off-white fabrics, cut:
4 strips, 2" x width of fabric

128 squares, 2" x 2"

64 rectangles, 2" x 3½"

From the assorted yellow fabrics, cut:
64 squares, 2" x 2"

From the assorted red fabrics, cut:
80 squares, 3½" x 3½"

From the turquoise print, cut:
9 strips, 2" x width of fabric; crosscut 2 strips into 8 pieces, 2" x 9½"

4 strips, 8" x width of fabric

6 binding strips, 2½" x width of fabric

From the red plaid or stripe, cut:
4 strips, 2" x width of fabric

Making the Blocks

1. Sew a 2"-wide brown strip to a 2"-wide off-white strip, lengthwise. Repeat to make a total of four strip sets. Press the seam allowance toward the brown strips. Cut the strip sets into 64 units, 2" wide.

2. Sew an off-white rectangle to each unit from step 1, as shown, to make the corner units. Press the seam allowance toward the rectangles.

Make 64.

3. Place a yellow square at one corner of a red square, right sides together. Sew diagonally across the yellow square. Trim to a ¼" seam allowance and press the seam allowance toward the triangle. Repeat in the opposite corner of the red square. Repeat for the two remaining corners to make a center unit. Repeat this step to make a total of 16 center units.

Make 16.

4. Place an off-white square at one corner of a red square, right sides together. Sew diagonally across the off-white square. Trim to a ¼" seam allowance and press the seam allowance toward the triangle. Repeat in the adjacent corner to make a side unit. Repeat this step to make a total of 64 side units.

Make 64.

5. Lay out the center, side, and corner units as shown. Sew the units into vertical rows. Press the seam allowances toward the red fabric. Sew the rows together to make each block. Press the seam allowances toward the brown squares.

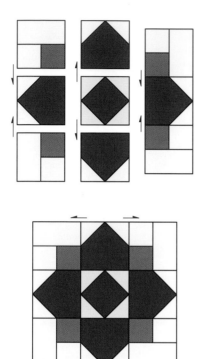

Make 16.

Assembling the Quilt Top

1. Sew 12 of the blocks and the eight 2" x 9½" sashing strips together into four rows. Press the seam allowances toward the sashing strips. Trim three of the 2"-wide turquoise strips to 30½" long. Sew the rows and 30½" sashing strips together to make the quilt center. Press the seam allowances toward the sashing strips.

2. Sew two of the remaining 2"-wide turquoise strips together, end to end, to make one long piece. Repeat with the final two strips. From each of these long pieces cut one sashing strip 41" long and one sashing strip 33½" long. Sew the 41" strips to the sides of the quilt,

and then sew the 33½" strips to the top and bottom of the quilt. Press all seam allowances toward the sashing.

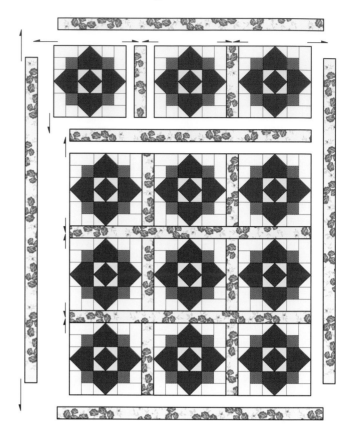

3. Sew two of the red strips together, end to end, to make one long piece. Repeat with the remaining two strips. From each of these long pieces cut one border strip 44" long and one border strip 33½" long. Sew the 44" strips to the sides of the quilt and press the seam allowances toward the red strips.

4. Sew two of the 8"-wide turquoise strips together, end to end, to make one long piece. Repeat with the remaining two strips. From each of these long pieces cut one border strip 44" long and one border strip 33½" long. Sew the 44" strips to the sides of the quilt as shown and press the seam allowances toward the turquoise strips.

5. Sew the 33½" red strips to the 33½" turquoise strips, lengthwise. Press the seam allowances toward the turquoise. Sew a pieced block to each end of each border unit as shown. Press the seam allowances toward the border units.

6. Sew these border units to the top and bottom of the quilt, placing the red border on the inside. Press the seam allowances toward the quilt center.

Finishing

Refer to "Quilting" on page 12 and "Binding Your Quilt" on page 13 for more detailed instructions on finishing techniques, if needed.

1. Piece the quilt backing so that it is 4" to 6" larger than the quilt top.

2. Layer the quilt top with batting and backing, and baste the layers together.

3. Quilt as desired and bind using your favorite method.

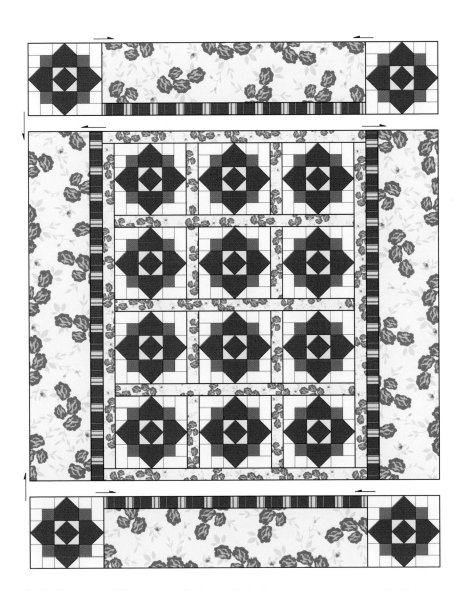

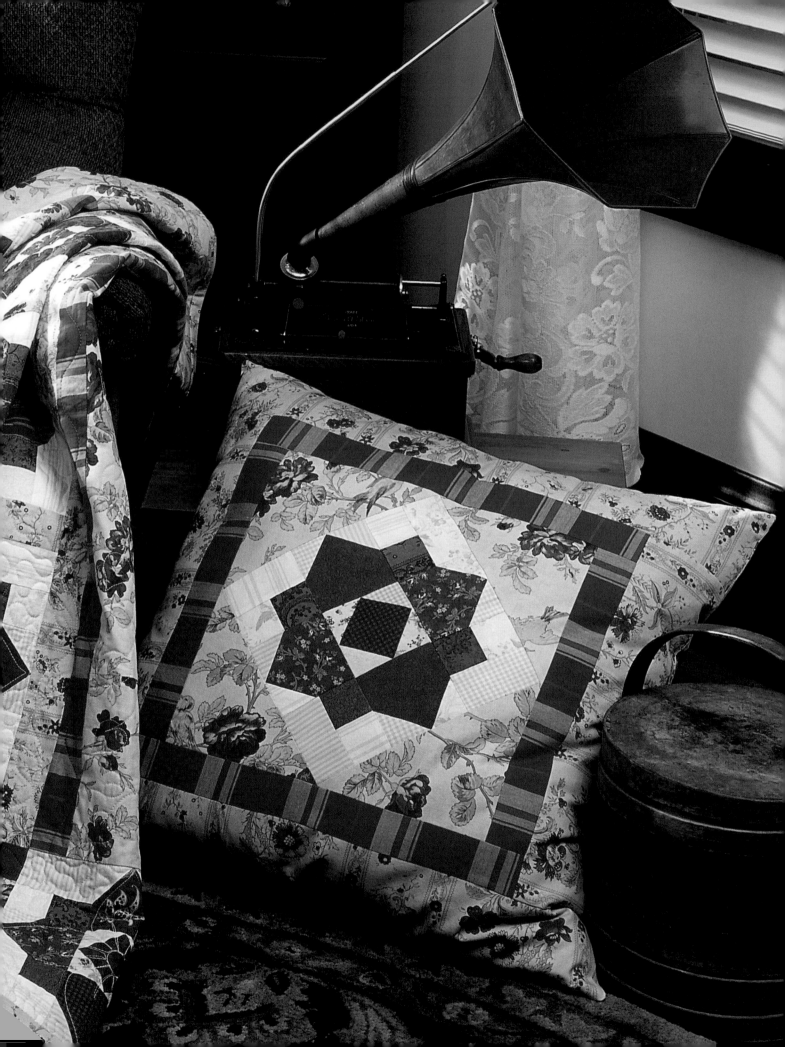

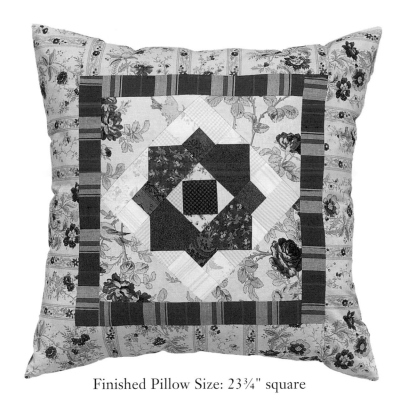

Finished Pillow Size: 23¾" square

Pillow Materials

Yardage is based on 42"-wide fabric. We assume that you'll have at least 40" of usable width after prewashing the fabric and trimming the selvages.

- 1½ yards of turquoise print for pillow top and back
- ¼ yard of red plaid or stripe for inner border
- Scraps of red, yellow, off-white, and brown fabrics for block
- 24" pillow form

Cutting

From the brown scraps, cut:
4 squares, 2" x 2"

From the off-white scraps, cut:
12 squares, 2" x 2"
4 rectangles, 2" x 3½"

From the yellow scraps, cut:
4 squares, 2" x 2"

From the red scraps, cut:
5 squares, 3½" x 3½"

From the turquoise print, cut:
1 strip, 7¼" x width of fabric; crosscut into 2 squares, 7¼" x 7¼", and cut once diagonally to yield 4 triangles

3 strips, 4½" x width of fabric; crosscut 1 strip into 2 pieces, 16¼" long, and trim the other 2 strips each to 24¼" long

2 pieces, 16" x 24¼"

From the red plaid or stripe, cut:
2 strips, 2" x width of fabric; crosscut *each* strip into 1 piece 16¼" long and 1 piece 13¼" long

Making the Pillow Top

1. Sew each brown square to an off-white square. Press the seam allowance toward the brown fabric.

2. Following steps 2–5 of "Making the Blocks" for "New Prairie Flower Quilt," make one block for the pillow center.

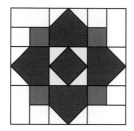

3. Sew a turquoise triangle to opposite sides of the center block. Then sew two more triangles to the two remaining sides. Press all seam allowances toward the triangles.

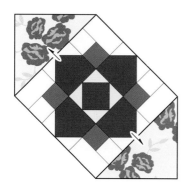

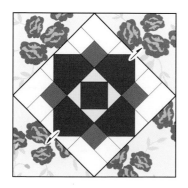

4. Sew the 13¼" red strips to the sides of the block, and then sew the 16¼" red strips to the top and bottom of the block. Press all seam allowances toward the red strips.

5. Sew the 16¼" turquoise strips to the sides of the pillow top, and then sew the 24¼" turquoise strips to the top and bottom of the pillow top. Press all seam allowances toward the turquoise strips.

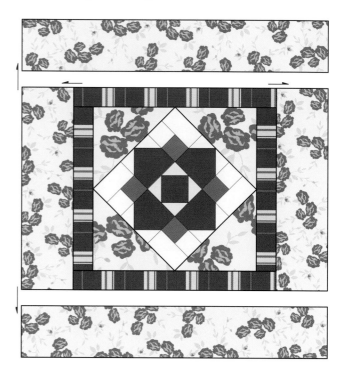

Completing the Pillow

1. Hem the long edge of each 16" x 24¼" turquoise piece with a ¼" double-rolled hem. (Fold under ¼" and then fold under ¼" again. Press to hold, and stitch in place.)

Make 2.

2. Place the pillow-back pieces, with the hems at the center, over the pillow front with right sides together and raw edges matching. The back pieces will overlap at the center. Sew around the perimeter of the pillow using a ¼" seam allowance.

3. Trim the corners, turn the pillow right side out, and press flat. Stuff with the 24" pillow form.

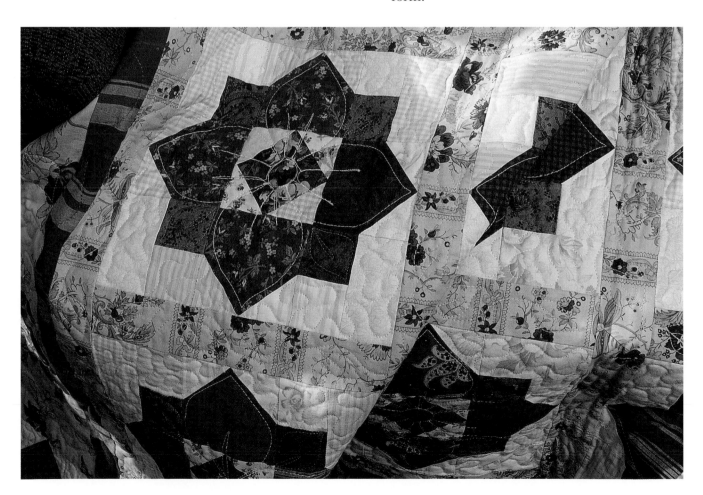

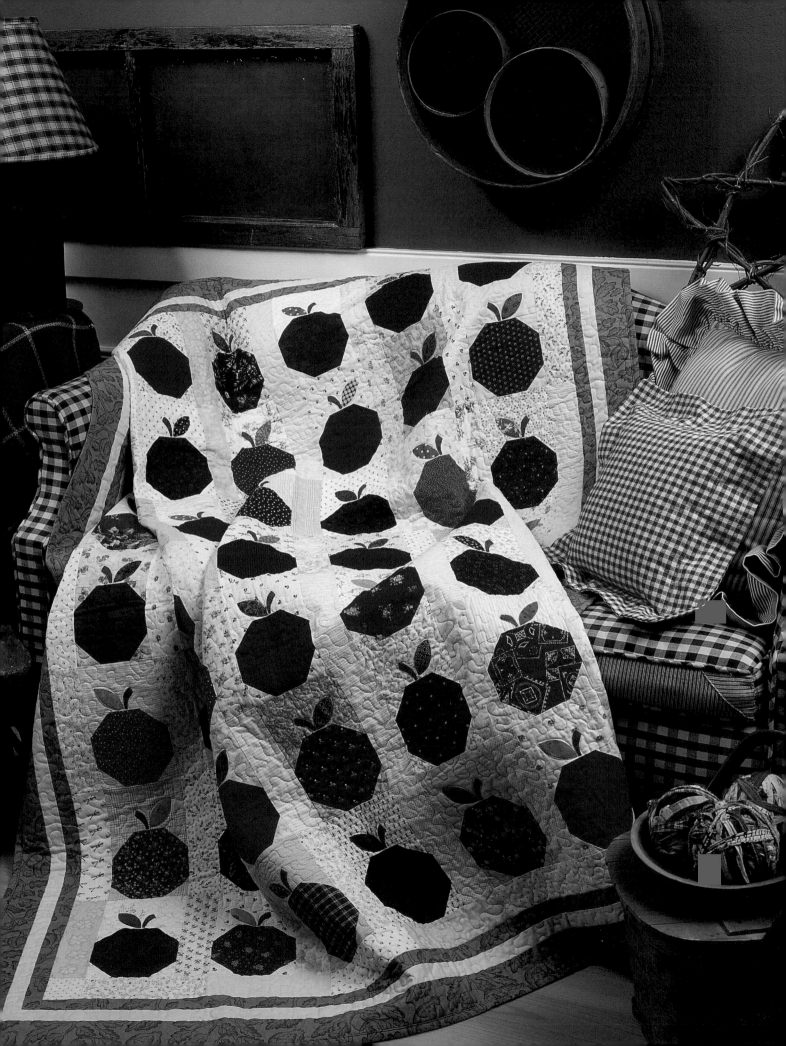

Apples

I smile every time I look at this quilt, because it reminds me of my days in Julian. Located near San Diego, California, Julian is a small country town known for its apples. Barbara and I sold quilts there 14 years ago, before we started publishing patterns. I drove up there once a month to drop off a new batch of quilts and always came home with an apple pie. Mom's Pie Shop was in the middle of town, with a big picture window so that the crowds could watch the dough being mixed and rolled. The aroma drifting out the door was heavenly. The line was long, but the wait was worth it.

You will love making this quilt—it is fun and easy. The apples are pieced, but the stems and leaves are machine appliquéd. Be sure to use many different shades of reds; you don't want them all the same.—Teri

Materials

Yardage is based on 42"-wide fabric. We assume that you'll have at least 40" of usable width after prewashing the fabric and trimming the selvages.

- 1½ yards of green fabric for first and third borders and binding
- ⅓ yard of tan fabric for second border
- ¼ yard *each* of 16 or more different light fabrics
- ¼ yard *each* of 7 or more different red fabrics (I recommend using more)
- ⅛ yard of brown fabric for stems
- Scraps of assorted green fabrics for leaves
- 4 yards of backing fabric
- 63" x 70" piece of batting
- ½ yard of fusible web

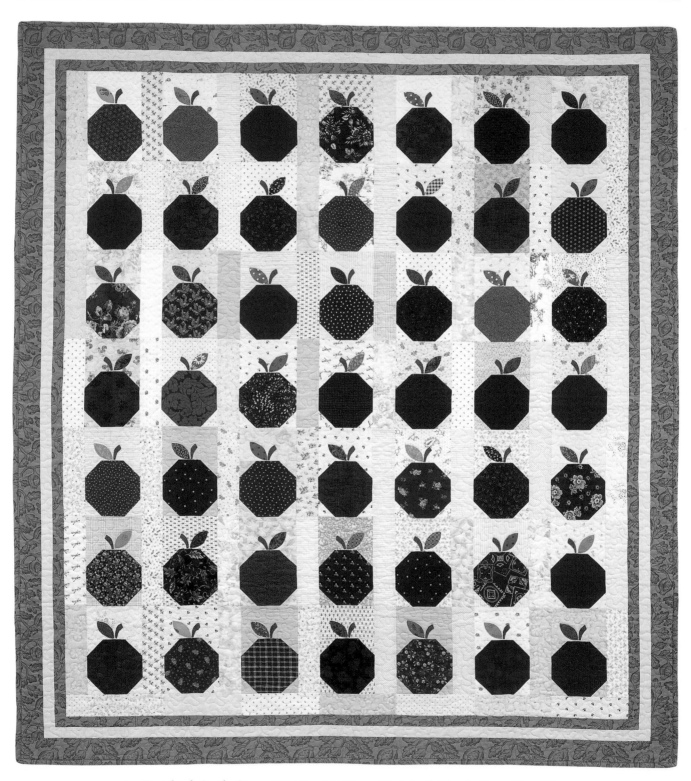

Finished Quilt Size: 59½" x 66½" • Finished Block Size: 5" x 8"

Cutting

Patterns for the leaves and stems are on page 69.

From the brown fabric, cut:

28 right-slanting stems

21 left-slanting stems

From the assorted green fabrics, cut:

49 leaves

From the red fabrics, cut:

49 squares, 5½" x 5½"

From the light fabrics, cut:

49 sets of 1 rectangle, 3½" x 5½", and 4 squares, 2" x 2", from the same fabric. (You can get 5 sets from ¼ yard.)

56 pieces, 2½" x 8½"

7 pieces, 2½" x 7½"

1 square, 2½" x 2½"

From the green fabric for borders and binding, cut:

6 strips, 1½" x width of fabric

7 strips, 2½" x width of fabric

7 binding strips, 2½" x width of fabric

From the tan fabric, cut:

6 strips, 1½" x width of fabric

Making the Blocks

1. Referring to "Using Fusible Web" on page 9, prepare the right-slanting brown stems, left-slanting brown stems, and green leaves for appliqué.

2. Using each of the 49 sets of light fabrics and the 49 red squares, make the apple blocks as follows. Place a light square on top of one corner of a red square, right sides together and raw edges even. Sew across the diagonal, as shown, and trim to a ¼" seam allowance. Press the seam allowance toward the triangle. Repeat on the remaining three corners of the red square to make an apple. Then sew the

matching light rectangle to the top of the apple. Repeat until you have made all 49 apple blocks.

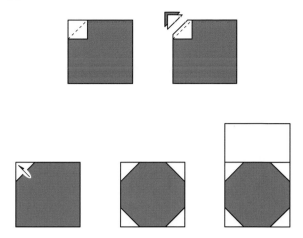

3. Position a stem and leaf above each apple. Make 28 stems slant to the right and 21 stems slant to the left. Iron to fuse in place. Appliqué the edges of the pieces with a machine blanket stitch and matching thread colors.

Right-Slanting Stem
Make 28.

Left-Slanting Stem
Make 21.

Assembling the Quilt Top

1. Sew seven apple blocks with right-slanting stems and eight 2½" x 8½" light pieces together as shown. Press the seam allowances toward the rectangles. Note that if you want your quilt to be scrappy, the fabric of the light rectangles should not be the same as the light fabric used in the neighboring apple blocks. Repeat until you have four of these right-slanting apple rows.

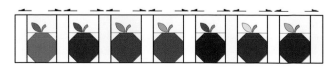

Right-Slanting Stems
Make 4.

2. Sew seven apple blocks with left-slanting stems and eight 2½" x 8½" light rectangles together as shown. Press the seam allowances toward the apples. Repeat until you have three of these left-slanting apple rows.

Left-Slanting Stems
Make 3.

3. Lay out the apple rows as shown, starting with a right-slanting row and alternating left- and right-slanting rows. Sew the rows together to create the quilt center and press the seam allowances toward the tops of the apples.

4. Sew the seven 2½" x 7½" light rectangles together, end to end. Sew the 2½" light square to the far left end to complete the bottom strip. Press the seam allowances toward the right. Sew this strip to the bottom of the apples to complete the quilt center. Press the seam allowance toward the strip.

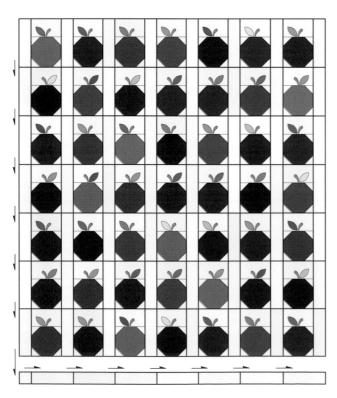

5. Sew three of the 1½"-wide green strips together, end to end, to create one long piece. Repeat with the remaining three strips. From each of these long pieces, cut one border strip 58½" long and one border strip 53½" long. Sew the two 58½" strips to the sides of the quilt, and then sew the 53½" strips to the top and bottom of the quilt. Press all seam allowances toward the green border.

6. Sew three of the tan strips together, end to end, to create one long piece. Repeat with the remaining three strips. From each of these long pieces, cut one border strip 60½" long and one border strip 55½" long. Sew the two 60½" strips to the sides of the quilt, and then sew the two 55½" strips to the top and bottom of the quilt. Press all seam allowances toward the tan border.

7. Sew the seven 2½"-wide green strips together, end to end, to create one long piece. From this piece, cut two borders 62½" long and two borders 59½" long. Sew the two 62½" borders to the sides of the quilt, and then sew the two 59½" borders to the top and bottom of the quilt. Press all seam allowances toward the outer green border.

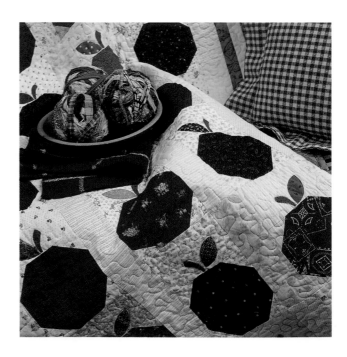

Finishing

Refer to "Quilting" on page 12 and "Binding Your Quilt" on page 13 for more detailed instructions on finishing techniques, if needed.

1. Piece the quilt backing so that it is 4" to 6" larger than the quilt top.

2. Layer the quilt top with batting and backing, and baste the layers together.

3. Quilt as desired and bind using your favorite method.

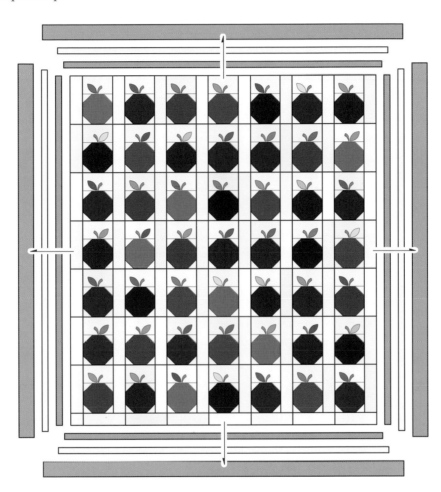

Appliqué Patterns

Patterns are reversed for fusible web appliqué.

Leaf **Stem** **Stem** **Leaf**

Left-Slanting Stem **Right-Slanting Stem**

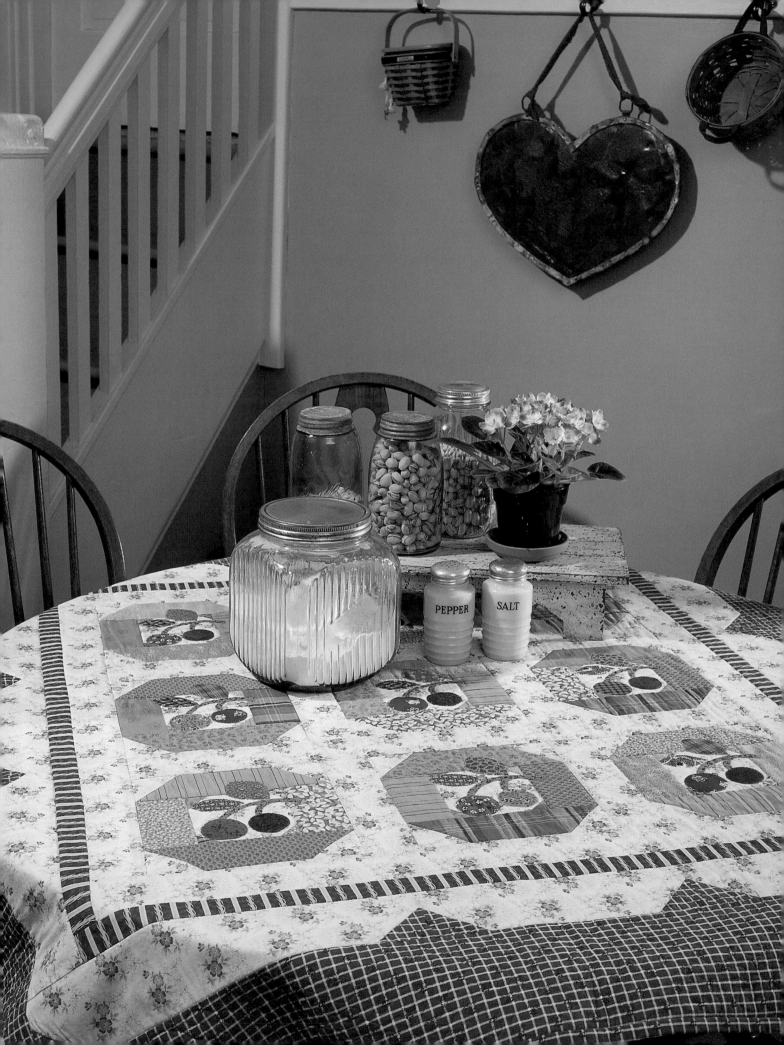

Cherries Quilt, Place Mat, Napkin, and Napkin Ring

Decorating a room is one of my favorite pastimes. Every winter I seem to feel a lull after Christmas, and that's when I hit the stores and start collecting paint chips and fabric swatches. I love the little frenzy of hunting for a bargain and finding the perfect decorator fabric and drapery rods. The whole process just lifts me right up. Like many people, I never seem to finish the look completely, and eventually I move on to another room the next year!

Lately, one of my favorite things to do is to design a room around a wall quilt. I love quilts in my home, and I don't worry about too many rules when using them. Quilts and quilted projects look great in every corner of the house. A throw quilt folded in a basket, or tossed over the arm of a chair, is one of my favorites. They are great on walls, and I especially love a quilted pillow, place mat, or table runner. —Barbara

Quilt Materials

Yardage is based on 42"-wide fabric. We assume that you'll have at least 40" of usable width after prewashing the fabric and trimming the selvages.

- 1⅞ yards of off-white print for blocks and borders
- 1⅝ yards of pink check for outer border and binding
- 1 yard of assorted green prints for blocks
- ¼ yard of brown stripe for inner border
- Scraps of assorted red, pink, green, and brown fabrics for appliqué
- ¾ yard of fusible web
- 3½ yards of backing fabric
- 56" x 56" piece of batting

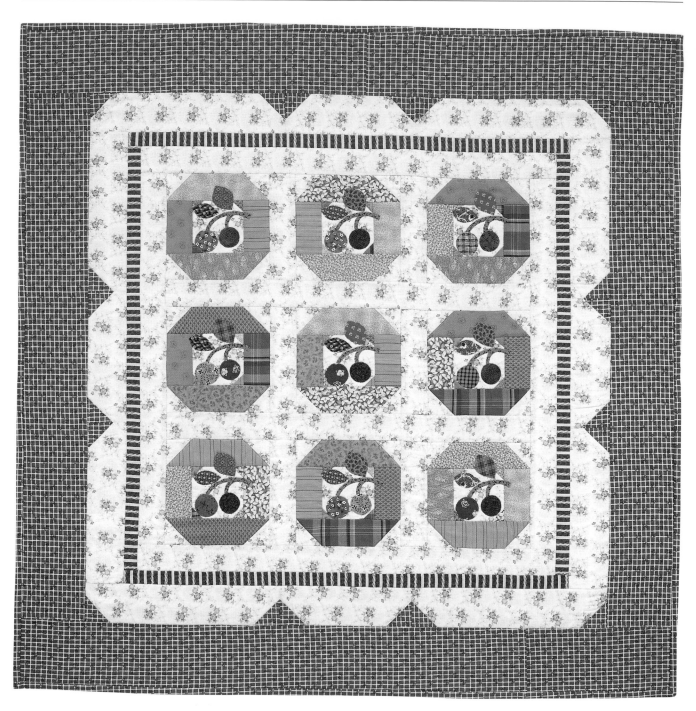

Finished Quilt Size: 50½" x 50½" • Finished Block Size: 8" x 8"

Cutting

Patterns for cherries, leaves, and stem are on page 82.

From the off-white print, cut:

2 strips, 4½" x width of fabric; crosscut into
9 squares, 4½" x 4½"

11 strips, 2½" x width of fabric; crosscut 3 strips
into 36 squares, 2½" x 2½", and crosscut
2 strips into 6 pieces, 2½" x 8½"

4 strips, 3½" x width of fabric; crosscut *each* strip
into 1 piece, 3½" x 10½", 1 piece, 3½" x 12½",
and 1 piece, 3½" x 15½"

From the assorted green prints, cut:

36 squares, 1⅜" x 1⅜"

18 pieces, 2½" x 4½"

18 pieces, 2½" x 8½"

From the red and pink scraps, cut:

9 large cherries

9 small cherries

From the green scraps, cut:

9 large leaves

9 small leaves

From the brown scraps, cut:

9 stems

From the brown stripe, cut:

4 strips, 1½" x width of fabric

From the pink check, cut:

2 strips, 2½" x width of fabric; crosscut into
20 squares, 2½" x 2½"

5 strips, 5½" x width of fabric

6 binding strips, 2½" x width of fabric

Making the Blocks

1. Place a 2½" off-white square at the end of a
2½" x 8½" green print piece, right sides
together. Sew diagonally across the square in
the direction shown. Trim to a ¼" seam
allowance and press the seam allowance
toward the triangle. Repeat at the other end

and note that the diagonal slants in the oppo-
site direction. Repeat this step to make a total
of 18 units.

Make 18.

2. Place a green square at a corner of a 4½"
off-white square, right sides together. Sew
diagonally across the green square. Trim to a
¼" seam allowance and press the seam
allowance toward the triangle. Repeat for the
remaining three corners. Repeat this step to
make a total of nine center units.

Make 9.

3. Sew two of the 2½" x 4½" green pieces to the
sides of each center unit and press the seam
allowances toward the green pieces. Sew the
units from step 1 to the top and bottom of
each block as shown. Press the seam
allowances toward the step 1 units.

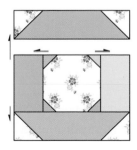 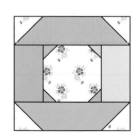

Make 9.

4. Referring to "Using Fusible Web" on page 9, prepare the cherries, leaves, and stems for appliqué. Use the placement diagram on page 83 to position the pieces on each block. Iron to fuse in place. Machine blanket stitch the edges of the pieces using matching thread colors.

Assembling the Quilt Top

1. Sew the blocks and the six 2½" x 8½" off-white sashing strips together into three rows. Press the seam allowances toward the sashing strips. Trim two of the 2½"-wide off-white strips to 28½" long. Sew the rows and 28½" sashing strips together to make the quilt center. Press the seam allowances toward the sashing strips.

2. Trim two of the 2½"-wide off-white strips to 28½" long and trim the remaining two of them to 32½" long. Sew the 28½" strips to the sides of the quilt, and then sew the 32½" strips to the top and bottom of the quilt. Press all seam allowances toward the sashing strips.

3. Trim two of the 1½"-wide brown strips to 32½" long and trim the other two to 34½" long. Sew the 32½" strips to the sides of the quilt, and then sew the 34½" strips to the top and bottom of the quilt. Press all seam allowances toward the brown fabric.

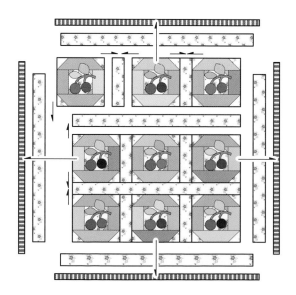

4. Place a pink square at a corner of a 3½" x 10½" off-white piece, right sides together. Sew diagonally across the square as shown. Trim to a ¼" seam allowance and press the seam allowance toward the triangle. Repeat at the opposite end of the piece on the same long side. Note that the diagonal slants in the opposite direction. Repeat to make a total of four 10½" units.

Make 4.

5. Sew a pink square to the left side of two 3½" x 12½" off-white pieces and sew a pink square to the right side of the remaining two 3½" x 12½" off-white pieces as in step 4.

Make 2.

Make 2.

6. Join a 12½" unit to each end of a 10½" unit as shown. Press the seam allowances in one direction. Make two of these borders for the sides of the quilt.

Make 2.

7. Place a pink square at a corner of a 3½" x 15½" off-white piece, right sides together. Sew diagonally across the square as shown. Trim to a ¼" seam allowance and press the seam allowance toward the triangle. Repeat at the opposite end of the piece on the same long side. Note that the diagonal slants in the opposite direction. Repeat to make a total of four 15½" units.

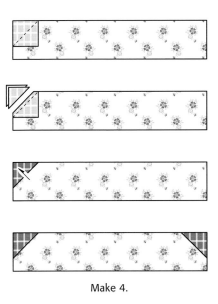

Make 4.

8. Join a 15½" unit to each end of a 10½" unit as shown. Press the seam allowances in one direction. Make two of these borders for the top and bottom of the quilt.

9. Sew the pieced borders from step 6 to the sides of the quilt. Then sew the pieced borders from step 8 to the top and bottom of the quilt. Press all seam allowances toward the pieced borders.

10. Join the five 5½"-wide pink strips, end to end, to make one long piece. From this piece cut two border strips 40½" long and two border strips 50½" long. Sew the 40½" strips to the sides of the quilt, and then sew the 50½" strips to the top and bottom of the quilt. Press all seam allowances toward the pink border.

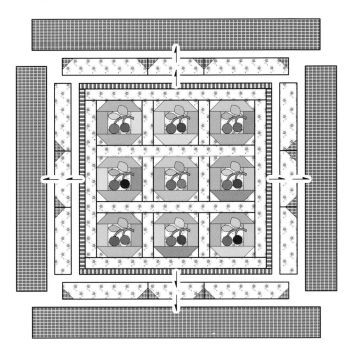

Finishing

Refer to "Quilting" on page 12 and "Binding Your Quilt" on page 13 for more detailed instructions on finishing techniques, if needed.

1. Piece the quilt backing so that it is 4" to 6" larger than the quilt top.

2. Layer the quilt top with batting and backing, and baste the layers together.

3. Quilt as desired and bind using your favorite method.

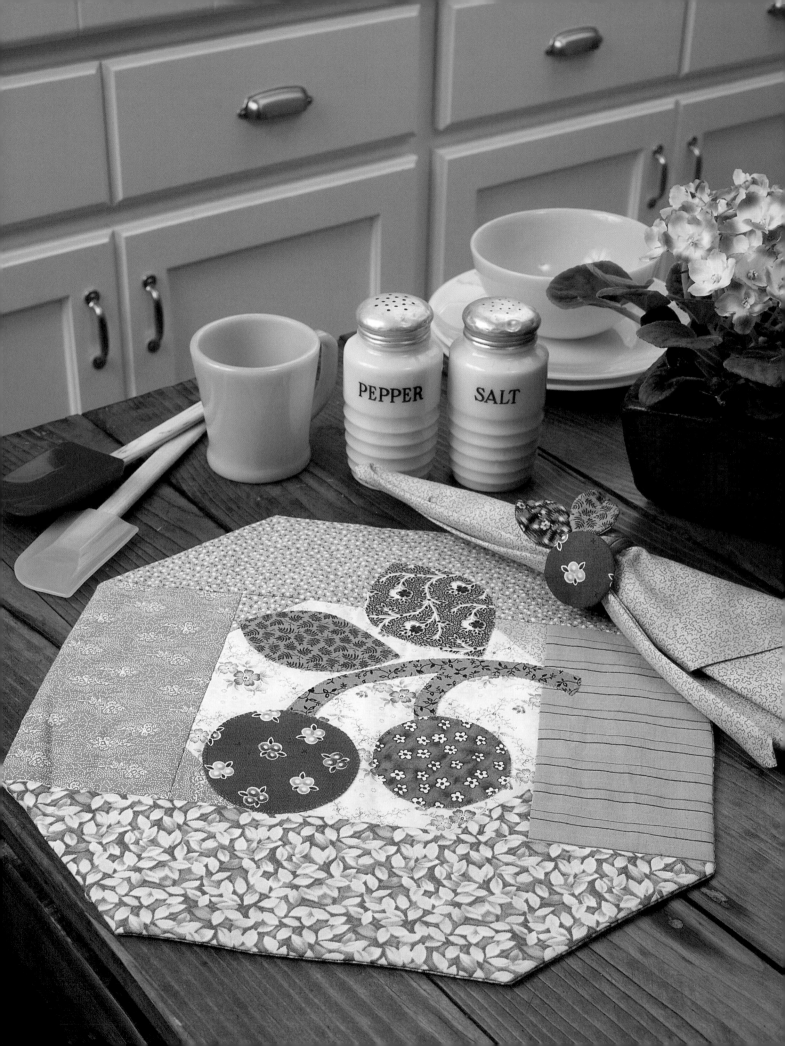

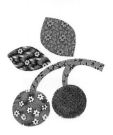

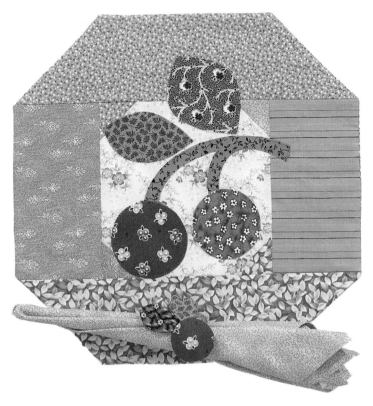

Finished Place Mat Size: 14" x 14"

Place Mat Materials
(for 2 place mats)

Yardage is based on 42"-wide fabric. We assume that you'll have at least 40" of usable width after prewashing the fabric and trimming the selvages.

- 4 large scraps of assorted green prints for place mat
- ¼ yard of off-white print for place mat
- Scraps of assorted red, pink, green, and brown fabrics for appliqué
- ½ yard of green fabric for back of place mat
- ½ yard of lightweight batting (48" wide)
- ½ yard of fusible web
- Template plastic

Cutting

Patterns for cherries, leaves, and stem are on page 84.

From the four green prints, cut an assortment of:

8 squares, 2" x 2"

4 pieces, 4" x 7½"

4 pieces, 4" x 15¼"

From the off-white print, cut:

2 squares, 7½" x 7½"

From the scrap of red, cut:

2 large cherries

From the scrap of pink, cut:

2 small cherries

From the scraps of green, cut:

2 large leaves

2 small leaves

From the scrap of brown, cut:

2 stems

From the green fabric for backing, cut:

2 squares, 14½" x 14½"

From the batting, cut:

2 squares, 16" x 16"

Making the Place Mat Front

1. For each place mat, trace the trimming template pattern on page 84 onto template plastic and cut out on the lines. Use this template to trim the two ends of each of the 4" x 15¼" green pieces as shown.

Make 4.

2. Place a green square at the corner of an off-white square, right sides together. Sew diagonally across the green square. Trim to a ¼" seam allowance and press the seam allowance toward the triangle. Repeat for the three remaining corners. Repeat this step to make a total of two center units.

Make 2.

3. Sew two of the 4" x 7½" green pieces to the sides of each center unit. Press the seam allowances toward the green pieces. Sew two of the 4" x 15¼" trimmed pieces to the top and bottom of each center unit as shown. Press the seam allowances toward the trimmed pieces.

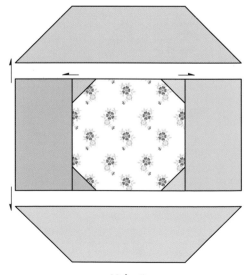

Make 2.

4. Referring to "Using Fusible Web" on page 9, prepare the cherries, leaves, and stems for appliqué. Use the placement diagram on page 85 to position the pieces on each place mat. Iron to fuse in place. Machine blanket stitch the edges of all the pieces using matching thread colors.

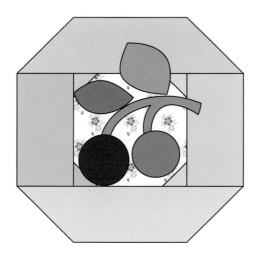

Completing the Place Mat

Layer each place mat set of front, backing, and batting as follows: Place the front and backing right sides together with the front on top, put the batting on the bottom, and pin through all layers. Stitch ¼" around the perimeter of the front, leaving a 5" opening for turning. Trim away the excess backing and batting, leaving a ¼" seam allowance. Trim the corners, turn the place mats right side out, and press flat. Stitch the opening shut. Quilt as desired.

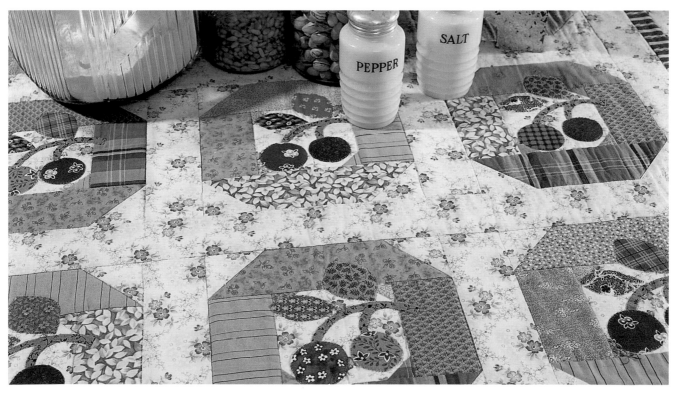

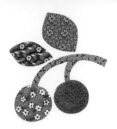

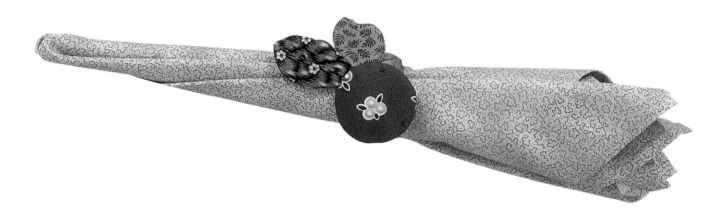

Napkin and Napkin Ring Materials
(for 2 napkins and napkin rings)

*Yardage is based on 42"-wide fabric. We assume that you'll have at least
40" of usable width after prewashing the fabric and trimming the selvages.*

- ¾ yard of green fabric for napkins
- Scraps of assorted pink and green fabrics for napkin rings
- Scraps of extra thin batting for napkin rings
- 2 wooden napkin rings
- Hot glue gun and glue

Cutting

From the green solid fabric, cut:
2 squares, 20" x 20"

Making the Napkins

Hem the napkins with a scant ¼" double-rolled hem (fold under a scant ¼", and then fold under a scant ¼" again). Press to hold and stitch in place. Press the hems flat.

Making the Napkin Rings

1. Using the cherry and leaf patterns on page 81, trace four cherries onto the back of the pink fabrics. Cut out the pieces, leaving an approximate ¼" seam allowance around the shapes. Cut two pieces of batting to match. Place two of the pink pieces right sides together, with one piece of batting on the bottom, and pin through all layers. Stitch around the perimeter of the cherry, exactly on

the tracing line, and trim the seam allowance to ⅛". Cut a small slit in the top piece, just large enough to turn the cherry inside out. Turn inside out and press. Hand stitch the opening shut.

Pencil line

¼" seam allowance

Trim seam allowance to ⅛". Cut slit for turning.

2. Trace four leaves and four leaves reversed onto the back of the green fabric. Repeat the process in step 2 to make four leaves. Using a needle and two strands of green thread, sew a running stitch down the center of each leaf, and pull the stitching taut before knotting the end on the back. This will make the leaf curl slightly.

Pencil line

¼" seam allowance

3. Position two leaves and one cherry in a pleasing arrangement and hand stitch them together in the back.

4. Using a hot glue gun, glue each cluster to a wooden napkin ring.

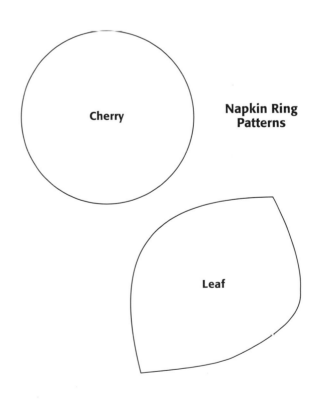

Cherry

Napkin Ring Patterns

Leaf

Quilt Appliqué Patterns

*Patterns are reversed for
fusible web appliqué.*

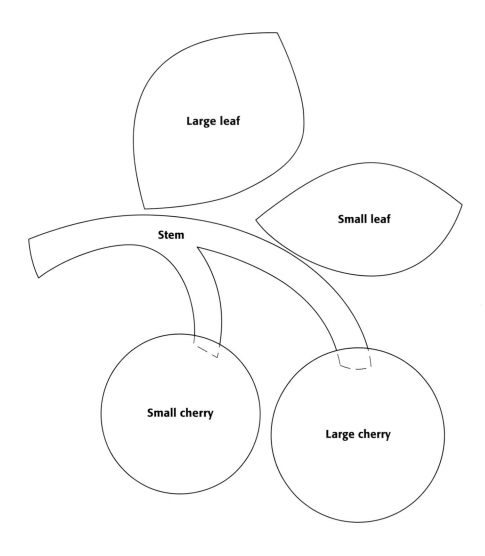

Large leaf

Small leaf

Stem

Small cherry

Large cherry

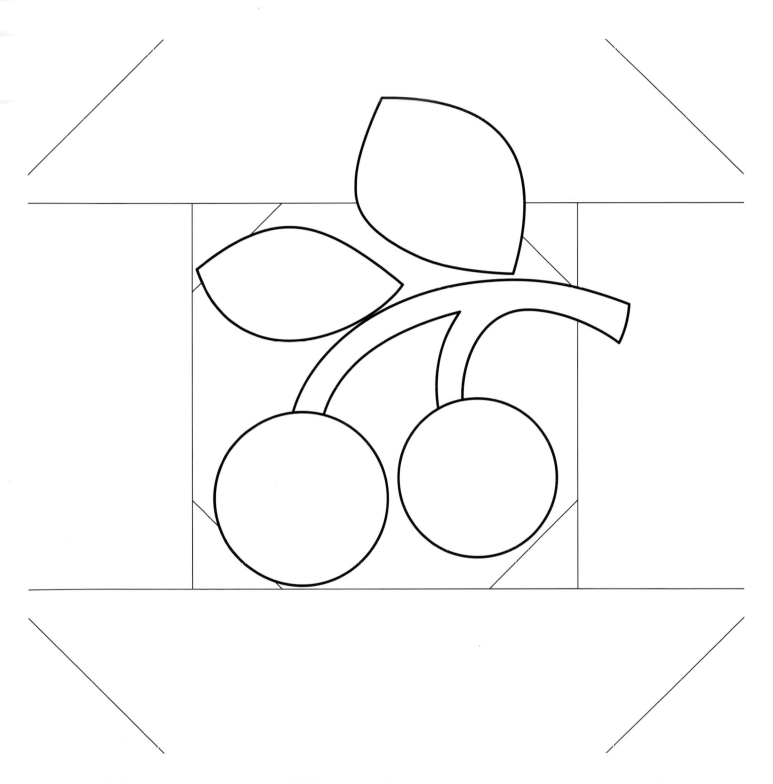

Quilt Appliqué Placement Diagram

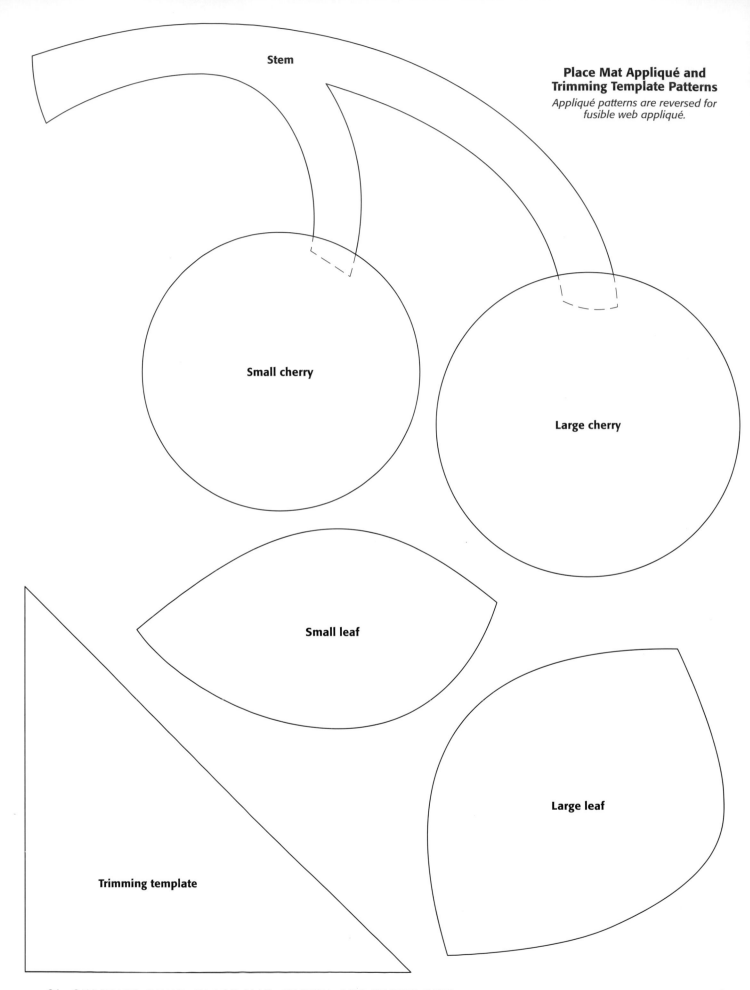

Stem

Place Mat Appliqué and Trimming Template Patterns
Appliqué patterns are reversed for fusible web appliqué.

Small cherry

Large cherry

Small leaf

Large leaf

Trimming template

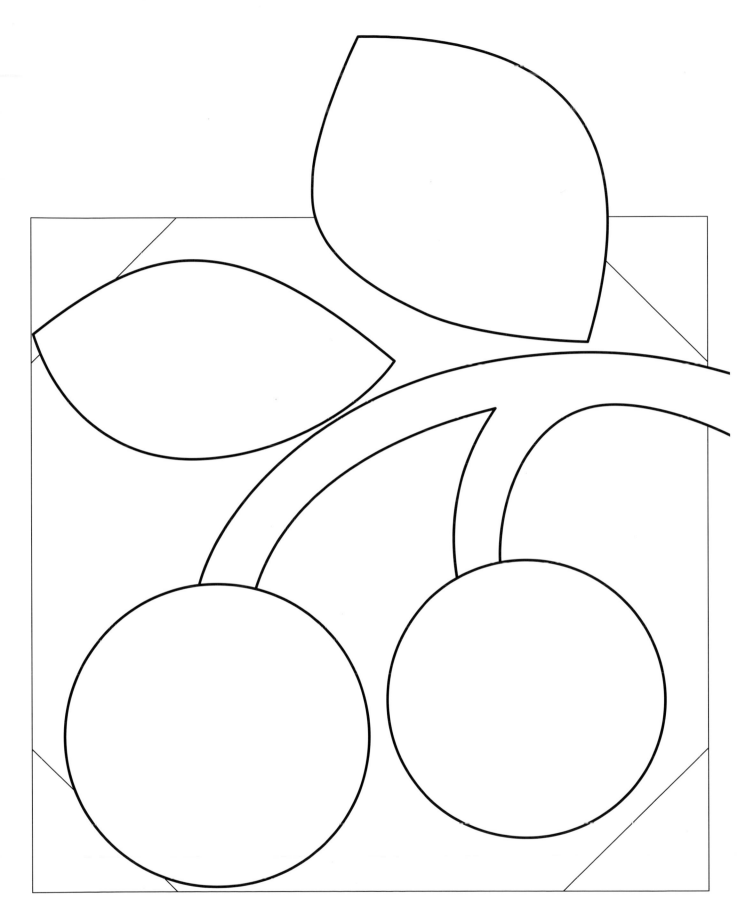

Place Mat Appliqué Placement Diagram

Cabin Posy

My first quilting adventure occurred while I was in college. Antique brass beds were in all the decorator magazines at the time, and I envisioned having one in my own home someday covered with a homemade quilt. I went to the dime store and bought dozens of prints to make a Log Cabin quilt. The rotary cutter hadn't been invented yet, so I just randomly cut 2"-wide strips of fabric by hand, and my blocks ended up being way off. However, that quilt became my children's favorite for many, many years. I've been decorating my rooms around quilts ever since. Quilts just seem to add the right character and coziness.

I wanted to make my sister-in-law a housewarming gift for her new family room, but I wanted my brother to feel like it was also for him. Their family loves the outdoors, and I thought this design would satisfy his masculine tastes, yet still be lovely for her.—Barbara

Materials

Yardage is based on 42"-wide fabric. We assume that you'll have at least 40" of usable width after prewashing the fabric and trimming the selvages.

- 2⅞ yards of blue print for sashing, borders, and binding
- 1½ yards *total* of assorted gold prints for blocks
- 1 yard of brown print for blocks and border
- ⅞ yard of gold fabric for borders
- ⅝ yard of red print for blocks and border
- Scraps of assorted blue prints for blocks
- 4¼ yards of backing fabric
- 68" x 81" piece of batting

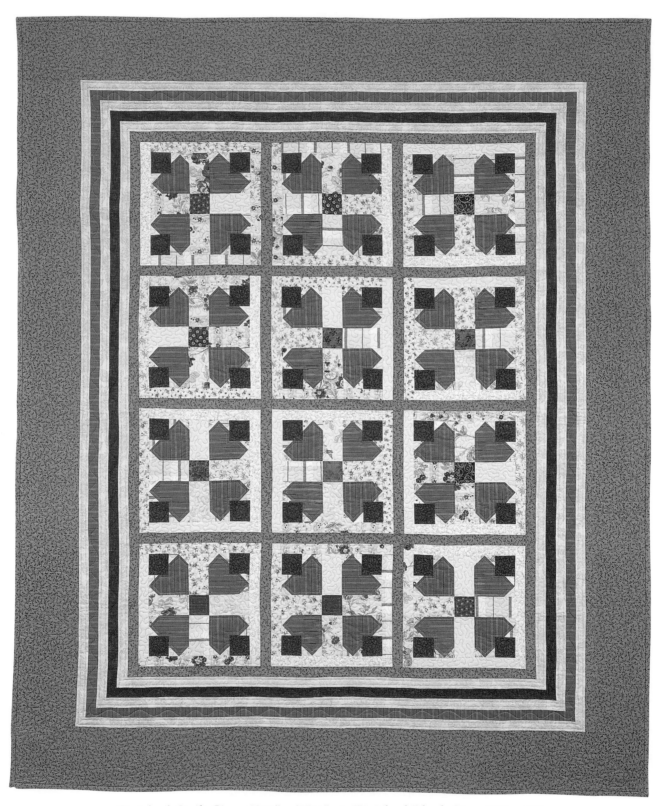

Finished Quilt Size: 62½" x 75½" • Finished Block Size: 12" x 12"

Cutting

From the assorted gold prints, cut:

48 pieces, 2½" x 4½"

192 squares, 1½" x 1½"

24 pieces, 1½" x 10½"

24 pieces, 1½" x 12½"

From the brown print, cut:

48 pieces, 2½" x 4½"

48 squares, 2½" x 2½"

6 strips, 1½" x width of fabric

From the red print, cut:

3 strips, 2½" x width of fabric; crosscut into
48 squares, 2½" x 2½"

6 strips, 1½" x width of fabric

From the assorted blue scraps, cut:

12 squares, 2½" x 2½"

From the blue print, cut:

11 strips, 1½" x width of fabric; crosscut 3 strips
into 8 pieces, 1½" x 12½"

7 strips, 6½" x width of fabric

8 binding strips, 2½" x width of fabric

From the gold fabric, cut:

16 strips, 1½" x width of fabric

Making the Blocks

1. Place a gold square at the corner of a brown
square, right sides together. Sew diagonally
across the gold square. Trim to a ¼" seam
allowance and press the seam allowance
toward the triangle. Repeat at the adjacent
corner. Repeat this step to make a total of
48 units.

Make 48.

2. Repeat step 1 using the remaining gold
squares and the 2½" x 4½" brown pieces to
make 48 units.

Make 48.

3. Sew the 48 red squares to the right side of
each small brown unit as shown. Join these
sections with each large brown unit as shown.
Press all seam allowances toward the red
fabric.

Make 48.

4. Lay out the 48 brown units, the 48 gold
2½" x 4½" pieces, and the 12 blue squares as
shown. Sew the gold pieces between the
brown units to make vertical rows. Press the
seam allowances toward the gold pieces. Sew
the blue squares between the gold pieces and
press the seam allowances toward the gold
pieces. Sew the rows together to make the
blocks. Press the seam allowances toward the
center strips.

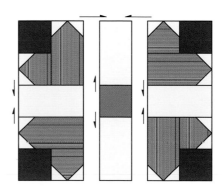

5. Sew a 1½" x 10½" gold piece to the sides of each block, and then sew a 1½" x 12½" gold piece to the top and bottom of each block. Press all seam allowances toward the strips.

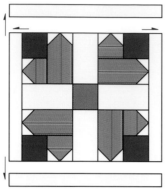

Make 12.

Assembling the Quilt Top

1. Sew the blocks and the eight 1½" x 12½" blue print sashing strips together into four rows. Press the seam allowances toward the sashing strips. Trim three of the 1½"-wide blue print strips to 38½" long. Sew the rows and 38½" sashing strips together to make the quilt center. Press the seam allowances toward the sashing strips.

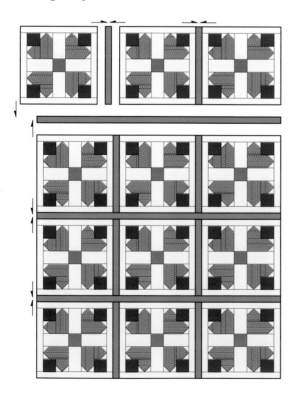

2. Sew the remaining five 1½"-wide blue print strips together, end to end, to make one long strip. From this strip cut two sashing strips 51½" long and two sashing strips 40½" long. Sew the 51½" strips to the sides of the quilt, and then sew the 40½" strips to the top and bottom of the quilt. Press all seam allowances toward the sashing.

3. Sew four of the gold fabric strips together, end to end, to make one long piece. From this piece cut two border strips 53½" long and two border strips 42½" long. Sew the 53½" strips to the sides of the quilt, and then sew the 42½" strips to the top and bottom of the quilt. Press all seam allowances toward the gold border.

4. Sew three of the red print strips together, end to end, to make one long piece. Repeat with the remaining three strips. From each of these long pieces cut one border strip 55½" long and one border strip 44½" long. Sew the 55½" strips to the sides of the quilt, and then sew the 44½" strips to the top and bottom of the quilt. Press all seam allowances toward the red border.

5. Sew three of the gold fabric strips together, end to end, to make one long piece. Repeat with three more strips. From each of these long pieces cut one border strip 57½" long and one border strip 46½" long. Sew the 57½" strips to the sides of the quilt, and then sew the 46½" strips to the top and bottom of the quilt. Press all seam allowances toward the gold border.

6. Sew three of the brown fabric strips together, end to end, to make one long piece. Repeat with the remaining three strips. From each of these pieces cut one border strip 59½" long and one border strip 48½" long. Sew the 59½" strips to the sides of the quilt, and then sew the 48½" strips to the top and bottom of the quilt. Press all seam allowances toward the brown border.

7. Sew three of the gold fabric strips together, end to end, to make one long piece. Repeat with the remaining three strips. From each of these pieces cut one border strip 61½" long and one border strip 50½" long. Sew the 61½" strips to the sides of the quilt and then sew the 50½" strips to the top and bottom of the quilt. Press all seam allowances toward the gold border.

8. Sew the seven 6½"-wide blue print strips together, end to end, to make one long piece. From this piece cut two border strips 63½" long and two border strips 62½" long. Sew the 63½" strips to the sides of the quilt and then sew the 62½" strips to the top and bottom of the quilt. Press all seam allowances toward the blue border.

Finishing

Refer to "Quilting" on page 12 and "Binding Your Quilt" on page 13 for more detailed instructions on finishing techniques, if needed.

1. Piece the quilt backing so that it is 4" to 6" larger than the quilt top.

2. Layer the quilt top with batting and backing, and baste the layers together.

3. Quilt as desired and bind using your favorite method.

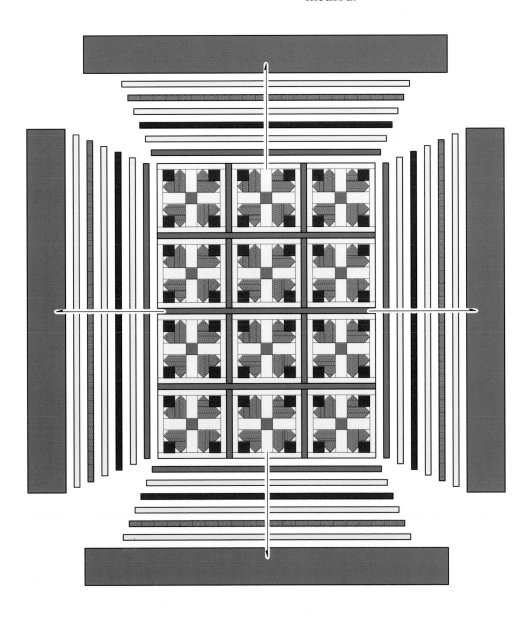

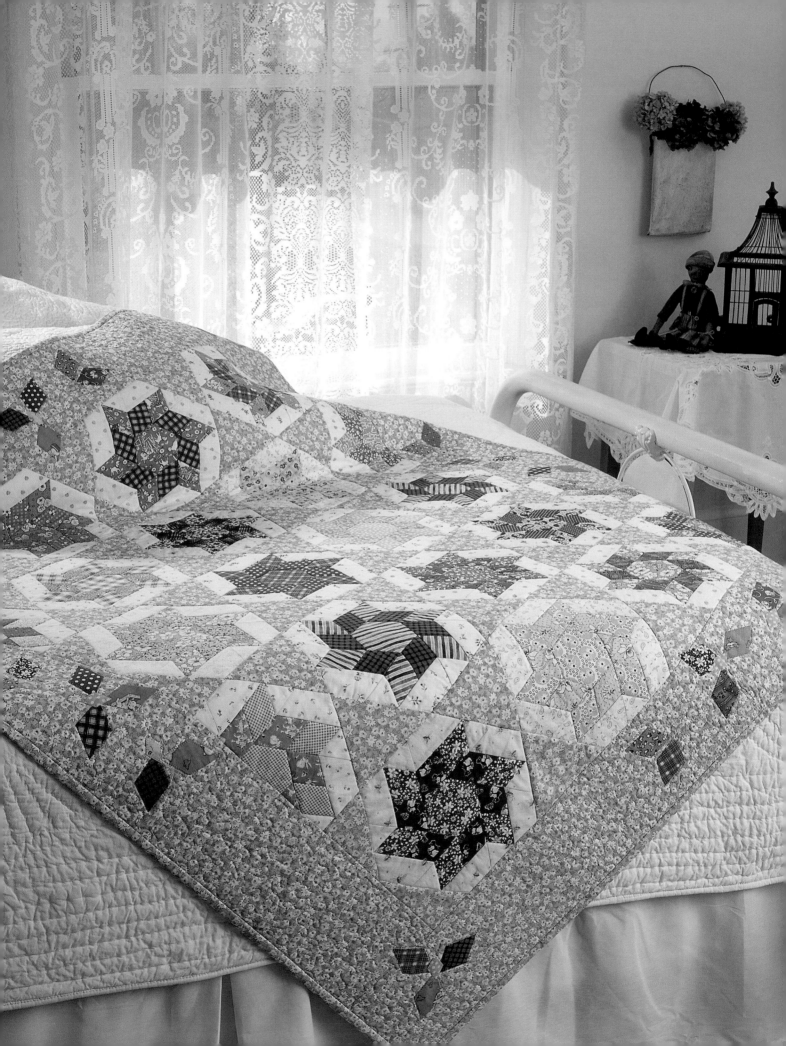

Salad Spinner

It's funny how we all acquire our own quilting style. When I start making a quilt, the presser foot goes down and I'm off. I guess you could say that I'm a speed piecer. I'll put off doing an errand or cooking dinner, because I can't wait to see those blocks get finished. It's not as though someone was handing out medals for being the world's fastest quiltmaker. But if anyone was, I just might enter the competition!

This traditional pattern has been adapted to be strip pieced quickly, and there are no inset seams. I wanted to honor my mother-in-law, who just retired at 86, and I thought reproduction fabrics would be traditional and pretty. This project would also look great in bright prints or traditional decorator colors.—Barbara

Materials

Yardage is based on 42"-wide fabric. We assume that you'll have at least 40" of usable width after prewashing the fabric and trimming the selvages.

- 2⅞ yards of blue print for background, border, and binding
- 2⅛ yards of white print for blocks
- 4 fat eighths *each*, of light pink print for blocks and appliqué
- 4 fat eighths *each*, of dark pink print for blocks and appliqué
- 3 fat eighths *each*, of light shades of orange, blue, purple, green, yellow, and red print (a total of 18 pieces) for blocks and appliqué
- 3 fat eighths *each*, of dark shades of orange, blue, purple, green, yellow, and red print (a total of 18 pieces) for blocks and appliqué
- 3¾ yards of backing fabric
- 60" x 63" piece of batting
- ¾ yard of fusible web
- Template plastic

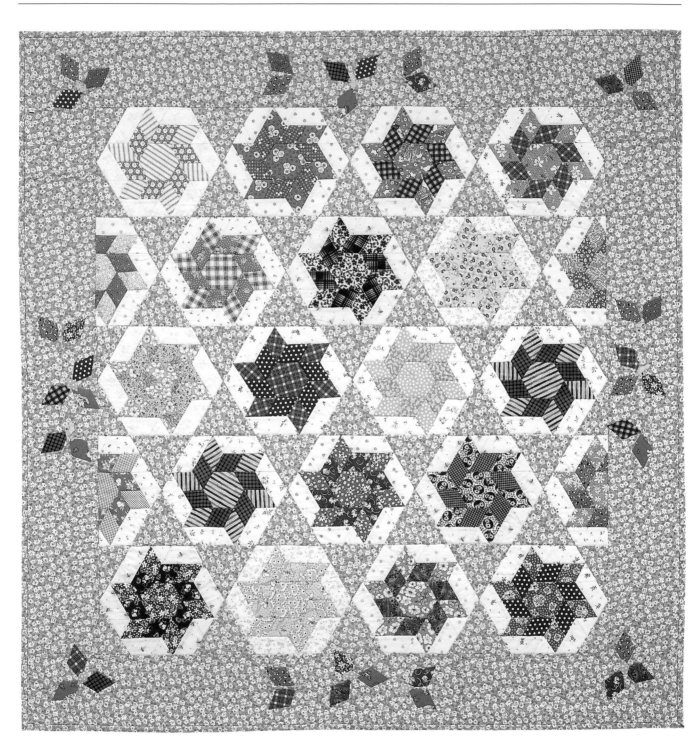

Finished Quilt Size: 54" x 57½" • Finished Block Size: 10⅜" x 9"

Cutting

Patterns for hexagon, triangle, petal/leaf, and flower center are on pages 100–101.

From *each* light print, cut:

1 strip, 2" x 20"

1 hexagon

From *each* dark print, cut:

1 strip, 2" x 20"

From the white print, cut:

11 strips, 2" x width of fabric; crosscut each strip into 2 strips, 20" long

7 strips, 6" x width of fabric; crosscut into 132 pieces, 2" x 6"

From the blue print, cut:

5 strips, 6½" x width of fabric

6 binding strips, 2½" x width of fabric

50 triangles

From the remainder of the light and dark pink, blue, purple, orange and red, cut:

24 petals

From the remainder of the light and dark greens, cut:

16 leaves

From the remainder of the light and dark yellows, cut:

16 flower centers

Making the Blocks

1. Trace the hexagon and triangle patterns on pages 100–101 and the trimming template patterns on page 99 onto template plastic and cut them out on the lines. Then also trace the dashed seam lines on the trimming templates.

2. Sew a light strip to a dark strip of the same color, lengthwise. Press the seam allowance toward the dark fabric. Sew a white strip to the light strip, lengthwise. Press the seam allowance toward the light fabric. You will make four different pink strip sets and three different orange, blue, purple, green, yellow, and red sets, for a total of 22 strip sets.

3. Use trimming template 1 to cut each strip set into six 2"-wide diagonal units. You can also use a ruler with 60° angled markings.

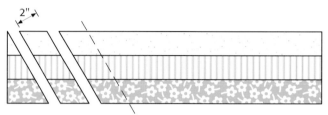

Cut 6 segments from each strip set.

4. Sew a 2" x 6" white piece across one long side of each diagonal unit and press the seam allowance toward the white fabric. Note that the dark fabric is on the left, and the white piece will overhang slightly at each end.

5. Use trimming template 2 to trim the sides of the pieces as shown. Be sure to leave a ¼" seam allowance past the point of the light fabric.

6. The pinwheel block is assembled with a technique similar to a Log Cabin block, in which you add pieces counterclockwise. Sew a pieced unit to a hexagon of the matching light print, but leave the seam open for 1¼" as shown. You will complete this portion of the seam last. Press the sewn seam allowance toward the pieced unit.

Leave seam open here.

7. Work counterclockwise to add another pieced unit, and press this seam allowance toward the pieced unit. Repeat to add the remaining four pieced units.

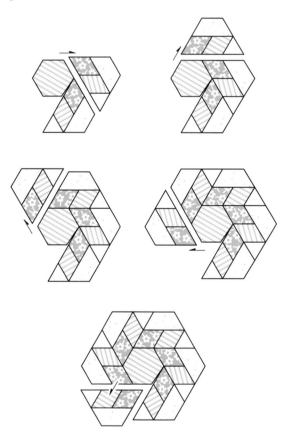

8. Now complete the remaining seam allowance from the first pieced unit. Make a total of four pink blocks and three in each of the other colors, for a total of 22 blocks.

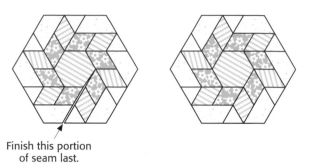

Finish this portion of seam last.

Assembling the Quilt Top

1. Sew a blue triangle to two opposite sides of each block as shown. Press the seam allowances toward the blue triangles.

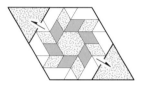

2. Lay out the blocks in a pleasing color arrangement, using the color photograph as a guide. The first, third, and fifth rows have four blocks each, and the second and fourth rows have five blocks each. (You will be trimming the sides of the rows to form a rectangular quilt top.) Sew the rows with four pinwheel blocks together and press the seam allowances toward the right. Sew an extra blue triangle at each end, as shown, and press the

seam allowances toward the triangles. Trim both ends of each row, ¼" past the hexagon block point, leaving a ¼" seam allowance.

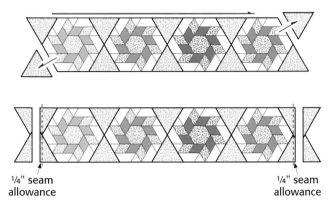

¼" seam allowance

¼" seam allowance

3. Sew the rows with five pinwheel blocks together and press the seam allowances toward the left. Fold in half the pinwheels at the ends of each row and press at the center-line. Trim ¼" past the fold line, leaving a ¼" seam allowance.

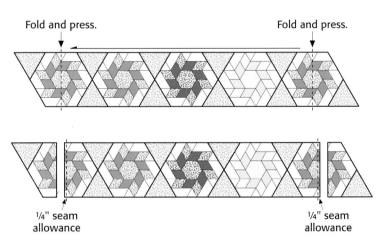

Fold and press.

Fold and press.

¼" seam allowance

¼" seam allowance

4. Sew the rows together to make the quilt center. Press the seam allowances in one direction.

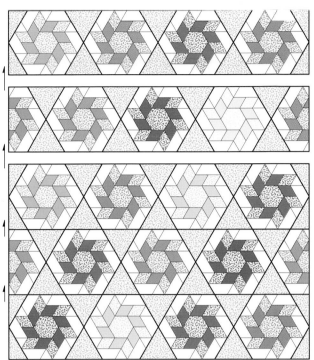

5. Sew the five 6½"-wide blue print strips together, end to end, to make one long piece. From this piece, cut two border strips 45½" long and two border strips 54" long. Sew the 45½" borders to the sides of the quilt and then sew the 54" borders to the top and bottom of the quilt. Press all seam allowances toward the blue border.

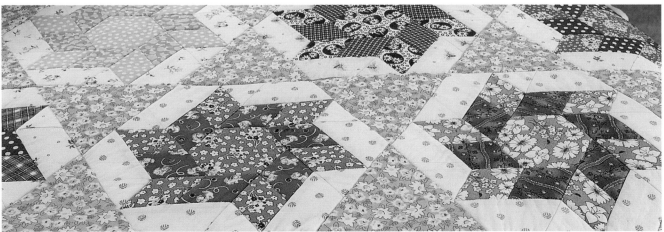

6. Referring to "Using Fusible Web" on page 9, prepare the petals, leaves, and flower centers for appliqué. Position the pieces around the border as shown. Iron to fuse in place. Machine blanket stitch around the edges of the pieces with matching thread color.

Finishing

Refer to "Quilting" on page 12 and "Binding Your Quilt" on page 13 for more detailed instructions on finishing techniques, if needed.

1. Piece the quilt backing so that it is 4" to 6" larger than the quilt top.

2. Layer the quilt top with batting and backing, and baste the layers together.

3. Quilt as desired and bind using your favorite method.

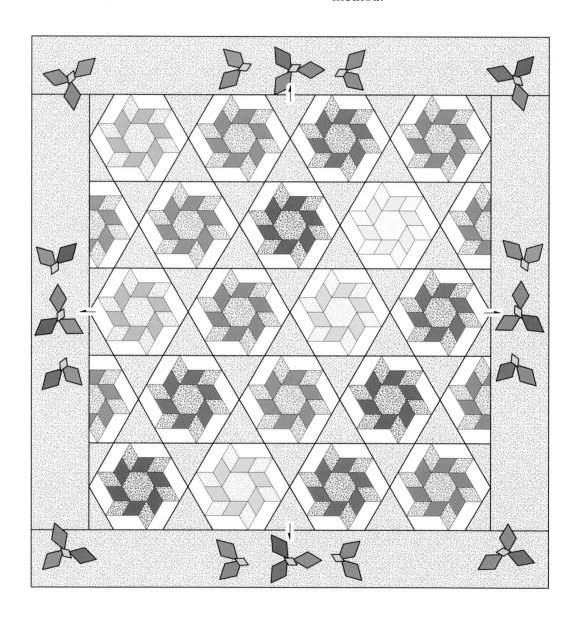

Trimming Template Patterns

Trimming template 1

Trimming template 2

Piecing and Appliqué Patterns

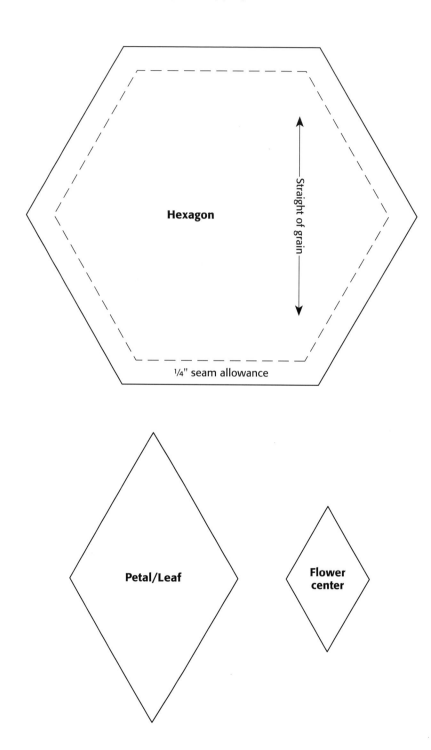

Hexagon

Straight of grain

¼" seam allowance

Petal/Leaf

Flower center

Piecing Pattern

Triangle

Straight of grain

¼" seam allowance

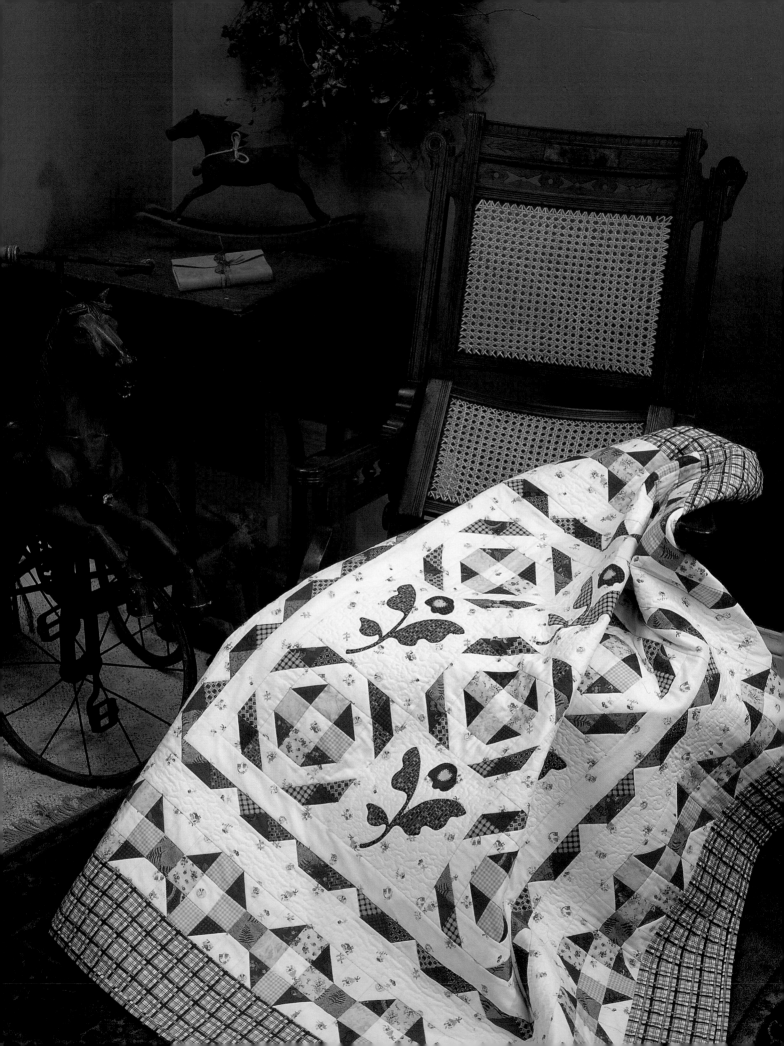

Mother's Day

Several years ago, my sisters and I were traveling when we discovered, almost by accident, the historical home of our great-great-grandmother. We burst into tears at the sight of it. The journal of this same grandmother tells us that she was well known for her skill with a needle. We even have one of her childhood samplers, faded and worn, but priceless to us. It is endearing to know that, for generations, women in our family have found joy in creating beautiful things. Our deepest connection is to our own mother, who taught us to sew and passed on the joy into our lives.

Traditional quilting patterns have been handed down from generation to generation, and today they are loved more than ever. It is fun to add a new twist by updating the color scheme or throwing in a personal touch, like adding an appliqué flower or a whimsical border. —Barbara

Materials

Yardage is based on 42"-wide fabric. We assume that you'll have at least 40" of usable width after prewashing the fabric and trimming the selvages.

- 2 yards of white print for blocks and borders
- 1⅜ yards of green plaid for outer border and binding
- ¼ yard *each* of four green prints for blocks and borders
- ¼ yard *each* of four yellow prints for blocks
- ¾ yard of assorted red prints for blocks and borders
- 3½ yards of backing fabric
- 56" x 56" piece of batting
- ¾ yard of fusible web
- Black embroidery floss

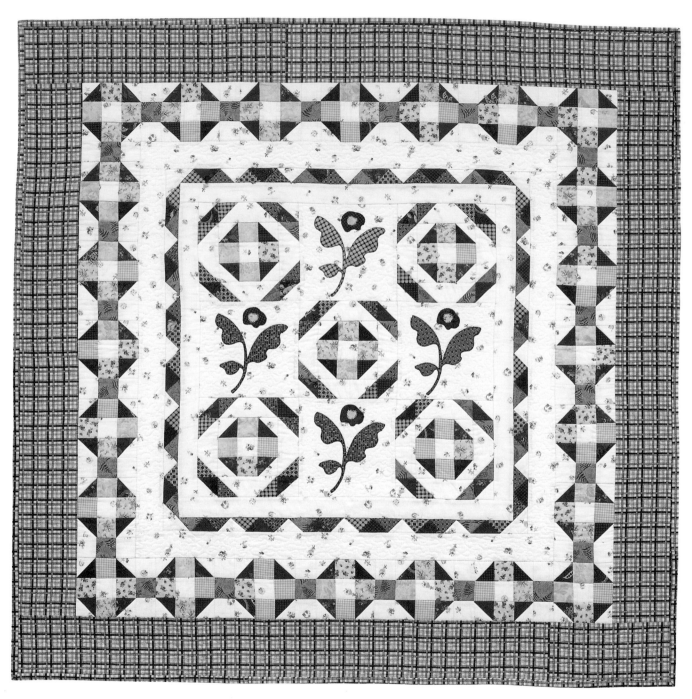

Finished Quilt Size: 50" x 50" • Finished Block Size: 7½" x 7½"

Cutting

Patterns for flower, flower center, and leaf are on page 109.

From the white print, cut:

11 strips, 2" x width of fabric; crosscut 1 strip into 20 squares, 2" x 2"

5 strips, 2⅜" x width of fabric; crosscut into 68 squares, 2⅜" x 2⅜"

1 strip, 5" x width of fabric; crosscut into 20 pieces, 2" x 5"

1 strip, 8" x width of fabric; crosscut into 4 squares, 8" x 8"

4 strips, 2½" x width of fabric

2 squares, 3" x 3"; cut once diagonally to yield 4 triangles

From the assorted red prints, cut:

68 squares, 2⅜" x 2⅜"

24 squares, 2" x 2"

4 flowers

From the assorted yellow prints, cut:

4 strips, 2" x width of fabric

58 squares, 2" x 2"

4 flower centers

From the assorted green prints, cut:

88 squares, 2" x 2"

2 strips, 2" x width of fabric

4 leaves

From the green plaid, cut:

5 strips, 5" x width of fabric

6 binding strips, 2½" x width of fabric

Making the Blocks

1. Draw a diagonal line across the back of each 2⅜" white square. Place each white square with a 2⅜" red square, right sides together. Sew ¼" from each side of the drawn line. Cut along the line and press the seam allowance toward the red fabric.

Make 136.

2. Sew a 2"-wide white strip between two yellow strips, lengthwise. Press the seam allowances toward the yellow fabric. Repeat to make two strip sets. Cut the strip sets into 29 segments, 2" wide.

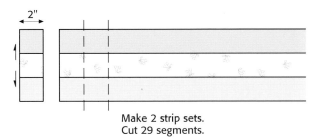

Make 2 strip sets.
Cut 29 segments.

3. Sew each yellow square between two red triangle squares, as shown, and press the seam allowances toward the yellow square. Sew two of these units to each side of a unit from step 2, as shown, to make the block centers. Press the seam allowances toward the center strip.

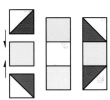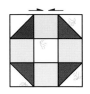

Make 29.

4. Place a green square at the end of each 2" x 5" white piece, right sides together. Sew diagonally across the square. Trim to a ¼" seam allowance and press toward the triangle.

Repeat at the opposite end of the white piece. Note that the diagonal slants in the opposite direction.

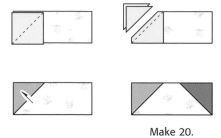

Make 20.

5. Sew a green section to each side of five of the block centers as shown. Press the seam allowances toward the green sections.

6. Sew a red triangle square to each end of the remaining green sections as shown. Press the seam allowances toward the green sections. Sew these sections to the top and bottom of the five blocks as shown. Press the seam allowances toward the green sections.

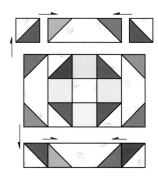

Make 5.

7. Referring to "Using Fusible Web" on page 9, prepare the flowers, flower centers, and leaves for appliqué. Position one of each piece on an 8" white square, referring to the placement diagram below. Iron to fuse in place. Machine or hand blanket stitch the edges with black thread.

Appliqué Placement Diagram

Assembling the Quilt Top

1. Lay out the five pieced blocks and the four appliqué blocks into three rows of three blocks each as shown. Sew the blocks into rows and press the seam allowances toward the appliqué blocks. Sew the rows together and press the seam allowances in one direction.

2. Trim two of the 2"-wide white print strips to 23" long and two of them to 26" long. Sew the 23" strips to the sides of the quilt, and then sew the 26" strips to the top and bottom of the quilt. Press all seam allowances toward the white border.

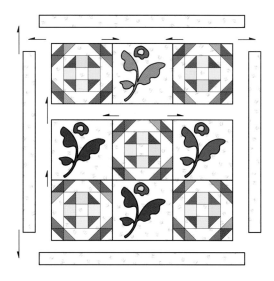

3. Sew 24 of the green squares to the 2" red squares. Sew 20 of the green squares to the 2" white squares. Press all seam allowances toward the green squares.

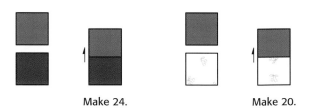

Make 24. Make 20.

4. Join six green-red units with five green-white units as shown. Line up the seam ¼" away from the end of the next unit. Sew an additional green square to one end.

Gently press the seam allowances in one direction, or your strip will stretch. Repeat to make four of these pieced units.

Make 4.

5. Trim the top and bottom of the pieced border units ¼" past the seam points. Note that these strips have bias cut edges and will stretch easily. Handle them with care to keep them the proper size.

6. Sew two of the pieced border units to the sides of the quilt, placing the green triangles next to the white border. Sew the remaining two border units to the top and bottom of the quilt, again placing the green triangles next to the white border. Press all seam allowances toward the white border. Sew the four white triangles to the corners of the quilt and press the seam allowances toward the triangles.

7. Trim two of the 2½"-wide white print strips to 28" long and trim the remaining two strips to 32" long. Sew the 28" strips to the sides of the quilt, and then sew the 32" strips to the top and bottom of the quilt. Press all seam allowances toward the white strips.

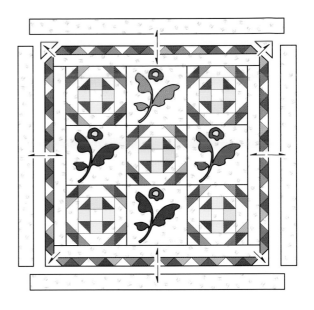

8. Sew a 2"-wide green print strip between two 2"-wide white print strips, lengthwise. Press the seam allowances toward the white strips. Repeat to make two strip sets. Cut the strip sets into a total of 24 units, 2" wide.

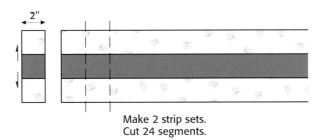

Make 2 strip sets.
Cut 24 segments.

9. Join five block centers with six green-white units as shown. Press the seam allowances toward the green units. Make two of these sections for the side borders.

10. Join seven block centers with six green-white units as shown. Press the seam allowances toward the green units. Make two of these sections for the top and bottom borders.

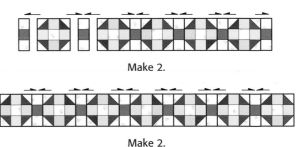

Make 2.

Make 2.

11. Sew the sections from step 9 to the sides of the quilt, and then sew the sections from step 10 to the top and bottom of the quilt. Press all seam allowances toward the white print border.

12. Sew the five 5"-wide green plaid strips together, end to end, to make one long strip. From this strip, cut two borders 41" long and two borders 50" long. Sew the 41" strips to the sides of the quilt, and then sew the 50" strips to the top and bottom of the quilt. Press all of the seam allowances toward the green plaid border.

Finishing

Refer to "Quilting" on page 12 and "Binding Your Quilt" on page 13 for more detailed instructions on finishing techniques, if needed.

1. Piece the quilt backing so that it is 4" to 6" larger than the quilt top.

2. Layer the quilt top with batting and backing, and baste the layers together.

3. Quilt as desired and bind using your favorite method.

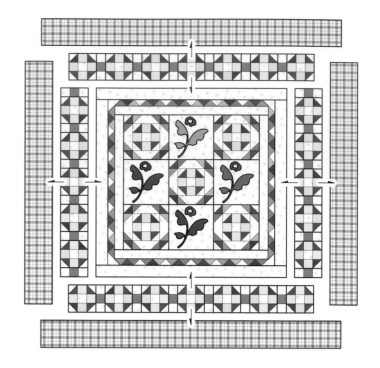

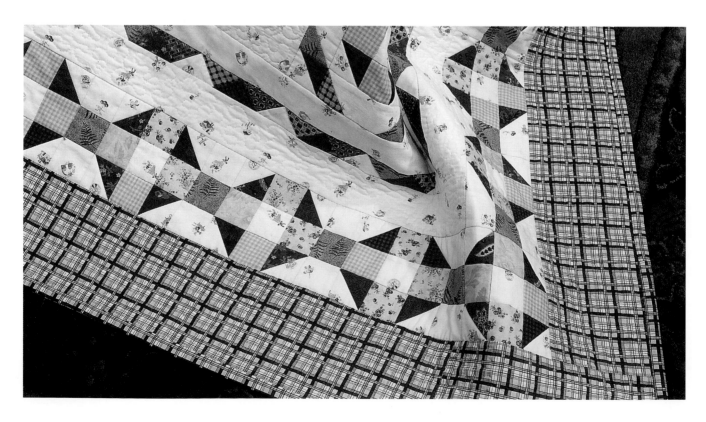

Appliqué Patterns

Patterns are reversed for fusible web appliqué.

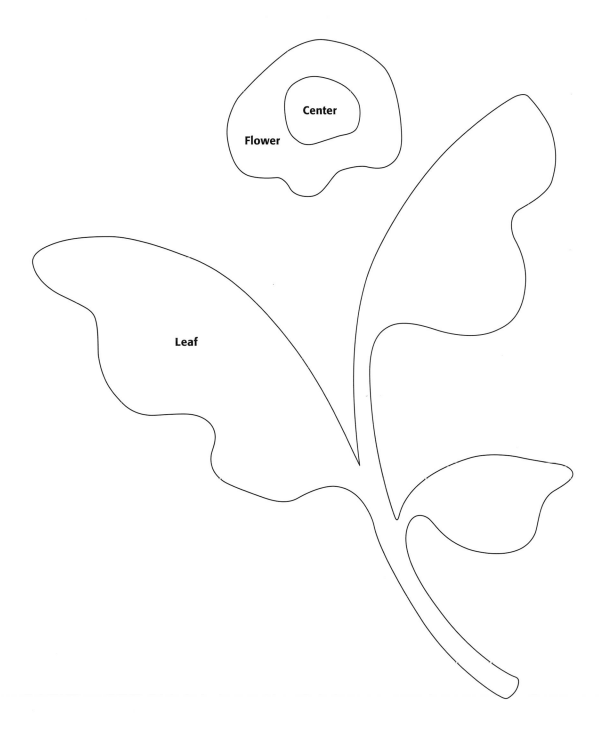

Center

Flower

Leaf

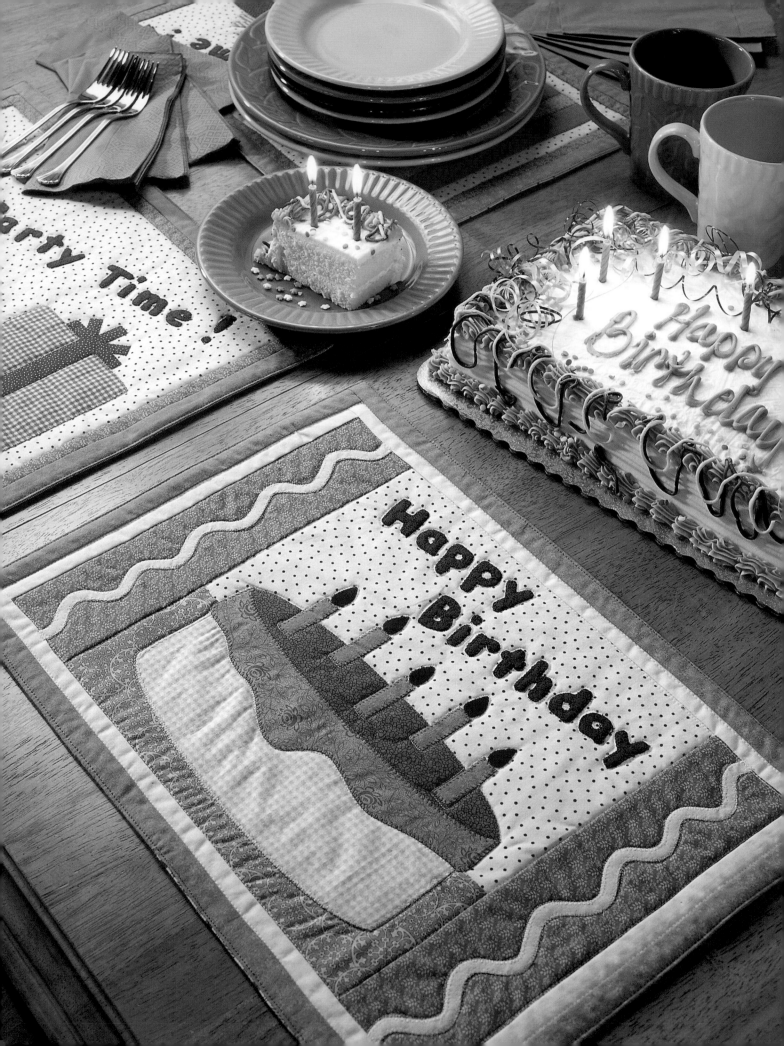

Birthday Place Mats

It's your special day! Pull out these festive birthday place mats whenever someone in your house turns another year older. This will quickly become a family tradition. Fusible appliqué makes the place mats so quick and easy, you can make an extra set for your sister or friend.

Last year, my friend Beth called the day before my birthday to ask what kind of cake I wanted. Then she showed up on my special day with a scrumptious, home-baked carrot cake with cream-cheese frosting. Yum! It was the perfect birthday present, especially since I'm unlikely to get a homemade cake otherwise, unless I bake it myself. I love the way women instinctively look out for one another. I'd be lost without my girlfriends.—Teri

Happy Birthday Cake
Place Mat Materials

Yardage is based on 42"-wide fabric. We assume that you'll have at least 40" of usable width after prewashing the fabric and trimming the selvages.

- ¼ yard of polka dot fabric for background
- ¼ yard of green print for table
- ¼ yard of yellow fabric for cake
- ⅛ yard of green fabric for outer border and candles
- ⅛ yard of dark pink fabric for top frosting
- ⅛ yard of light pink fabric for side frosting
- ⅛ yard of dark blue fabric for letters
- ⅛ yard of medium blue fabric for side borders
- ⅛ yard of white fabric for streamers and inner borders
- Scrap of red fabric for flames
- ⅝ yard of backing fabric
- 17" x 22" piece of thin batting
- ½ yard of fusible web

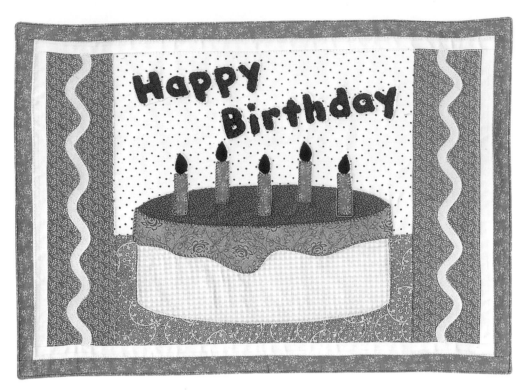

Finished Place Mat Size: 18½" x 13½"

Cutting

Patterns for cake, top frosting, side frosting, candles, flames, streamers, and letters are on pages 117–119.

From the polka dot fabric, cut:
1 rectangle, 7½" x 11½"

From the green print, cut:
1 rectangle, 4½" x 11½", for table

From the yellow fabric, cut:
1 cake

From the dark pink fabric, cut:
1 top frosting

From the light pink fabric, cut:
1 side frosting

From the green fabric, cut:
2 strips, 1¼" x width of fabric; crosscut 1 strip into 2 pieces, 1¼" x 12½", and crosscut 1 strip into 2 pieces, 1¼" x 19"

5 candles

From the red scrap, cut:
5 flames

From the dark blue fabric, cut:
1 set of "Happy Birthday" letters

From the white fabric, cut:
2 strips, 1" x width of fabric; crosscut 1 strip into 2 pieces, 1" x 11½", and crosscut 1 strip into 2 pieces, 1" x 17½"

2 streamers

From the medium blue fabric, cut:
2 rectangles, 3" x 11½"

From the backing fabric, cut:
1 piece, 17" x 22"

Making the Place Mat Front

1. Sew the polka dot rectangle and the green print rectangle for table together, lengthwise. Press the seam allowance toward the green print.

2. Referring to "Using Fusible Web" on page 9, prepare the cake, top frosting, side frosting, candles, flames, "Happy Birthday" letters, and streamers for appliqué.

3. Position the cake, frostings, candles, flames, and letters onto the pieced block as follows: Place the yellow cake first, with the cake bottom approximately 1" above the bottom edge of the fabric. Place the dark pink top frosting above the cake, overlapping the cake side ¼". Then place the light pink side frosting at the top edge of the cake, overlapping the top frosting ¼". Next place the candles on top of the frosting, with the flames added to the top of the candles. Arrange the letters to spell "Happy Birthday," leaving at least 1" between the tops of the letters and the top edge of the fabric. Iron to fuse in place. Appliqué the edges with a machine blanket stitch and matching thread colors.

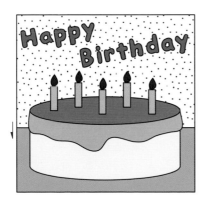

4. Position one white streamer on each of the two medium blue rectangles. Iron to fuse in place. Appliqué the edges with a machine blanket stitch and white thread. Sew these blue rectangles to the sides of the cake block and press the seam allowances toward the blue fabric.

5. Sew the two 1" x 11½" white strips to the sides of the place mat, and then sew the two 1" x 17½" white strips to the top and bottom of the place mat. Press all seam allowances toward the white borders.

6. Sew the two 1¼" x 12½" green strips to the sides of the place mat, and then sew the two 1¼" x 19" green strips to the top and bottom of the place mat. Press all seam allowances toward the green borders.

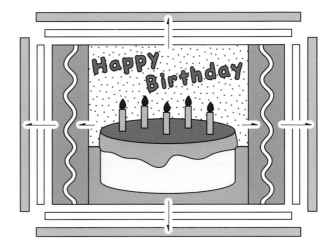

Completing the Place Mat

1. Lay the 17" x 22" piece of thin batting on your sewing table. Place the 17" x 22" piece of backing fabric on top of the batting, right side up. Place the place mat front on top of the backing, wrong side up. Pin the edges of the place mat front through all layers.

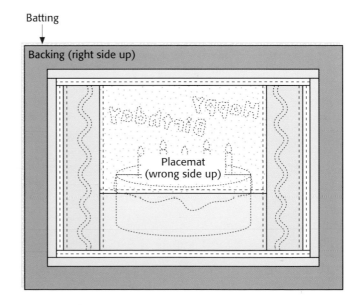

2. Sew around the edges of the place mat front, using a ¼" seam allowance and leaving an 8" opening for turning. To more easily guide the three layers through your machine, use a walking foot if you have one. Double stitch the corners to reinforce them.

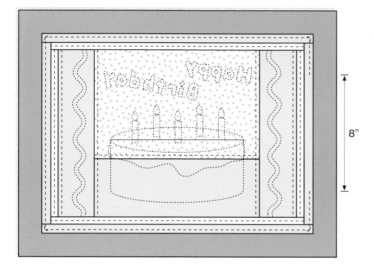

8"

3. Cut off the excess batting and backing even with the place mat front, leaving a ¼" seam allowance. Reduce bulk in the corners by clipping them diagonally, being careful not to cut the stitching.

4. Turn the place mat right side out. Carefully poke out the corners until the place mat is "squared off." Press the outer edge flat, tucking in the ¼" seam allowance at the opening as you press. Edgestitch the place mat by sewing ¹⁄₁₆" from the edge all the way around, sealing the opening shut as you go. Quilt the place mat as desired.

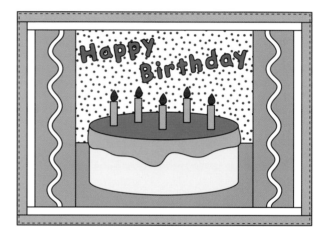

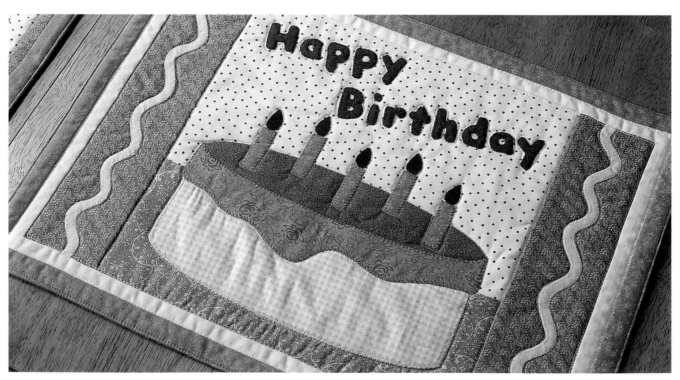

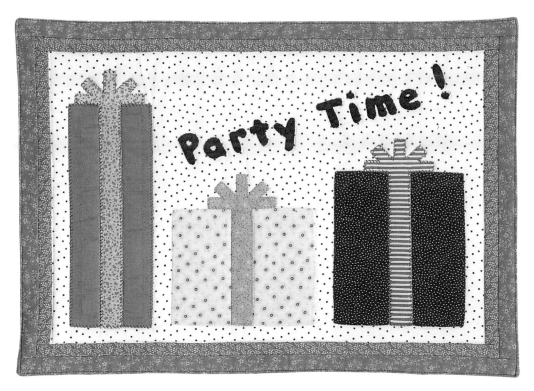

Finished Place Mat Size: 18½" x 13½"

Party Time! Place Mat Materials

Yardage is based on 42"-wide fabric. We assume that you'll have at least 40" of usable width after prewashing the fabric and trimming the selvages. The yardage listed will make one place mat; when making multiple place mats, add even more variety and color to your party by choosing different package and ribbon fabrics for each one.

- 1 fat quarter of polka dot fabric for background
- ¼ yard *each* of 3 different package fabrics
- ⅛ yard *each* of 3 different ribbon fabrics
- ⅛ yard of medium blue fabric for inner border
- ⅛ yard of green fabric for outer border
- ⅛ yard of dark blue fabric for lettering
- ⅝ yard of backing fabric
- 17" x 22" piece of thin batting
- ½ yard of fusible web

Cutting

Patterns for packages, ribbons, and letters are on pages 119–121.

From the 3 package fabrics, cut one each:
Package 1
Package 2
Package 3

From the 3 ribbon fabrics, cut one each:
Ribbon 1
Ribbon 2
Ribbon 3

From the dark blue fabric, cut:
1 set of "Party Time!" letters

From the polka dot fabric, cut:
1 rectangle, 11½" x 16½"

From the medium blue fabric cut:
2 strips, 1" x 11½"
2 strips, 1" x 17½"

From the green fabric cut:
2 strips, 1¼" x 12½"
2 strips, 1¼" x 19"

From the backing fabric, cut:
1 piece, 17" x 22"

Making the Place Mat Front

1. Referring to "Using Fusible Web" on page 9, prepare the packages, ribbons, and letters for appliqué.

2. Position the packages, ribbons, and "Party Time!" letters on the polka dot rectangle. Position the bottom edges of the boxes

approximately ⅞" above the bottom edge of the fabric. Iron to fuse in place. Appliqué the edges with a machine blanket stitch and matching thread colors.

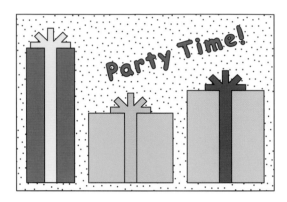

3. Sew the two 1" x 11½" medium blue strips to the sides of the place mat, and then sew the two 1" x 17½" medium blue strips to the top and bottom of the place mat. Press all seam allowances toward the blue border.

4. Sew the two 1¼" x 12½" green strips to the sides of the place mat and then sew the two 1¼" x 19" green strips to the top and bottom of the place mat. Press all seam allowances toward the green border.

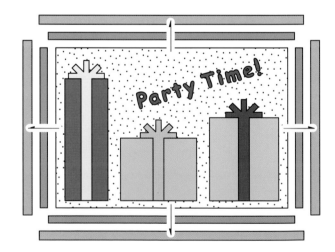

Completing the Place Mat

Refer to "Completing the Place Mat" on page 113 to finish your project.

Appliqué Patterns

Patterns are reversed for fusible web appliqué.

Flame

Candle

Top frosting

Side frosting

Cake

Appliqué Pattern

Pattern is reversed for fusible web appliqué.

Streamer

Appliqué Patterns

*Patterns are reversed for
fusible web appliqué.*

Appliqué Patterns

Package 1 Ribbon 1

Package 3

Ribbon 3

Appliqué Patterns

Package 2 **Ribbon 2**

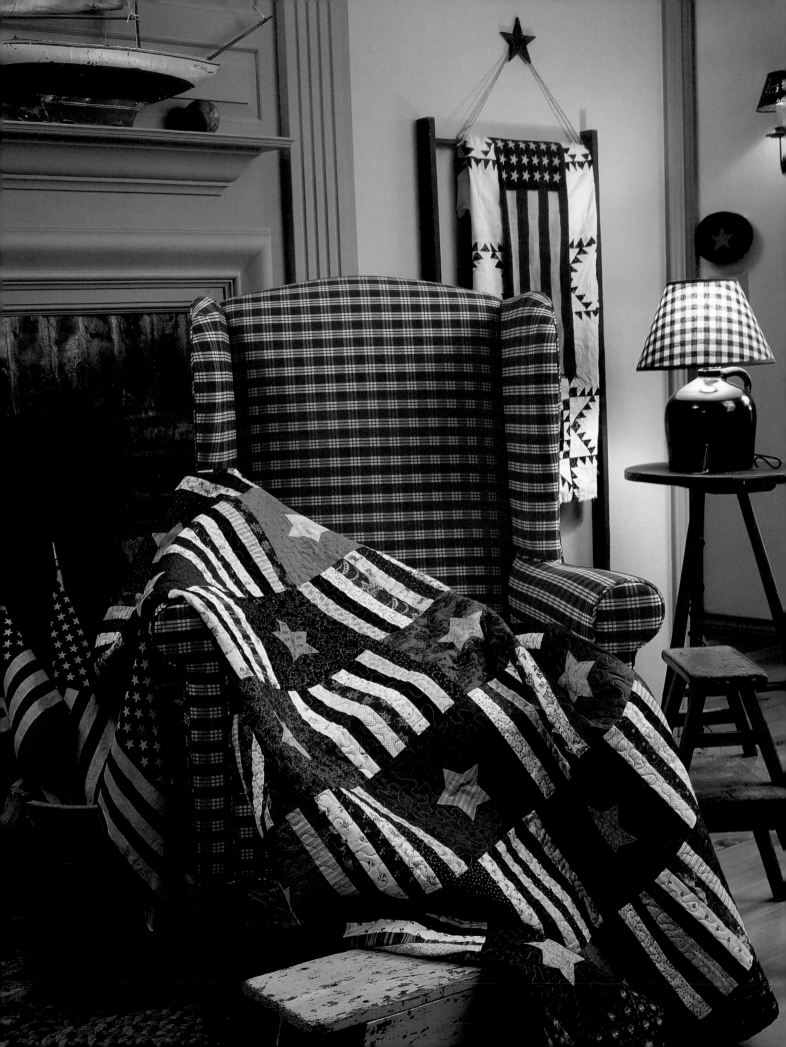

Fourth of July

I decorate my home with a lot of red, white, and blue, so patriotic quilts fly year-round at my house. This one is quick and easy, thanks to big pieces and fusible appliqué.

My husband, Mark, and I take our kids to the beach every Fourth of July, along with a large group of friends and their kids. Someone needs to go down early in the morning to reserve a spot—usually me. I carry beach umbrellas and folding chairs and spread out a blanket to claim our territory. Gradually, the sun rises and the masses arrive. We body surf and nap and eat homemade chocolate chip cookies, and then barbeque hot dogs for dinner. As the sun settles into the ocean, we pull on sweatshirts and curl up to watch the fireworks above the pier. The kids are sleepy as we carry them back to the car. In my opinion, that's the perfect way to celebrate the Fourth of July.—Teri

Materials

Yardage is based on 42"-wide fabric. We assume that you'll have at least 40" of usable width after prewashing the fabric and trimming the selvages.

- ¾ yard of blue print for outer border
- ⅓ yard *each* of 7 or more different blue fabrics
- ⅛ yard *each* of 12 or more different red fabrics
- ⅛ yard *each* of 12 or more different light fabrics
- ⅛ yard *each* of 4 or more different yellow/gold fabrics
- 4 yards of backing fabric
- ⅝ yard of binding fabric
- 66" x 66" piece of batting
- 1 yard of fusible web
- Gold/yellow embroidery floss

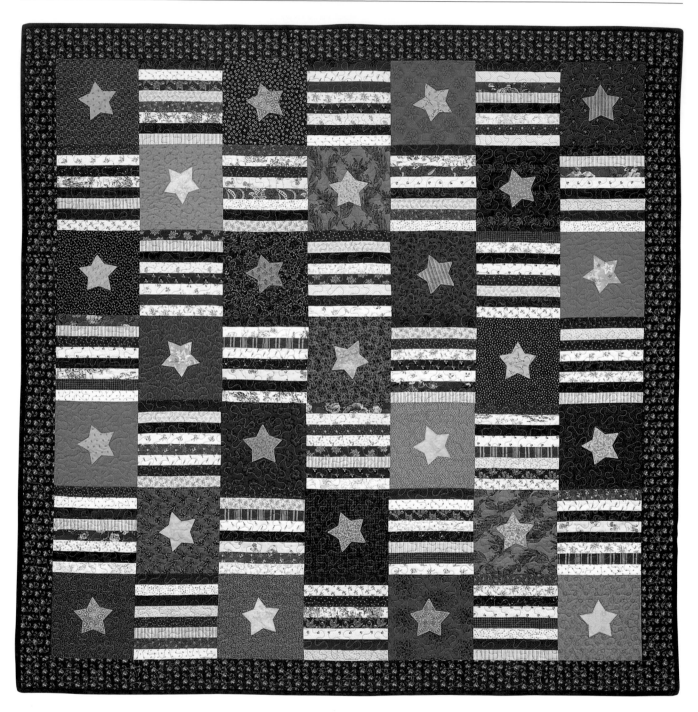

Finished Quilt Size: 62½" x 62½" • Finished Block Size: 8" x 8"

Cutting

Pattern for star is on page 127.

From the many yellow/gold fabrics, cut:
25 stars

From the many blue fabrics, cut:
25 squares, 8½" x 8½"

From the many red fabrics, cut:
96 strips, 1½" x 8½"

From many light fabrics, cut:
96 strips, 1½" x 8½"

From the blue print, cut:
6 strips, 3½" x width of fabric

From the binding fabric, cut
7 strips, 2½" x width of fabric

Making the Blocks

1. Referring to "Using Fusible Web" on page 9, prepare the stars for appliqué.

2. Position one star in the center of each 8½" blue square and iron to fuse in place. The stars should not all point straight upward; rotate them at different angles to give the quilt movement. Appliqué the edges with a machine blanket stitch and gold/yellow thread.

Make 25.

3. Sew four different red strips and four different light strips together lengthwise, alternating colors. Press the seam allowances toward the red strips. Repeat with the remaining red and white strips until you have 24 of these striped blocks.

Make 24.

Assembling the Quilt Top

1. Arrange the 25 star blocks and the 24 striped blocks into seven rows of 7 blocks each as shown. Position the striped blocks so that a red stripe is on the top. Move the blocks around until the brightest, darkest, and busiest fabrics are evenly distributed across the quilt. *Tip:* After your blocks are arranged, number them 1 through 49 with a water-soluble fabric marker. Then you can pick up the blocks and sew them together without forgetting which block goes where.

2. Sew the blocks together into rows and press the seam allowances toward the star blocks. Sew the rows together to make the quilt center. Press these seam allowances in one direction.

3. Sew three of the blue print 3½"-wide strips together, end to end, to create one long piece. Repeat with the remaining three strips. From each of these pieces cut one border strip 56½" long and one border strip 62½" long. Sew the 56½" strips to the sides of the quilt, and then sew the 62½" strips to the top and bottom of the quilt. Press all seam allowances toward the border.

Finishing

Refer to "Quilting" on page 12 and "Binding Your Quilt" on page 13 for more detailed instructions on finishing techniques, if needed.

1. Piece the quilt backing so that it is 4" to 6" larger than the quilt top.

2. Layer the quilt top with batting and backing, and baste the layers together.

3. Quilt as desired and bind using your favorite method.

Appliqué Pattern

Star

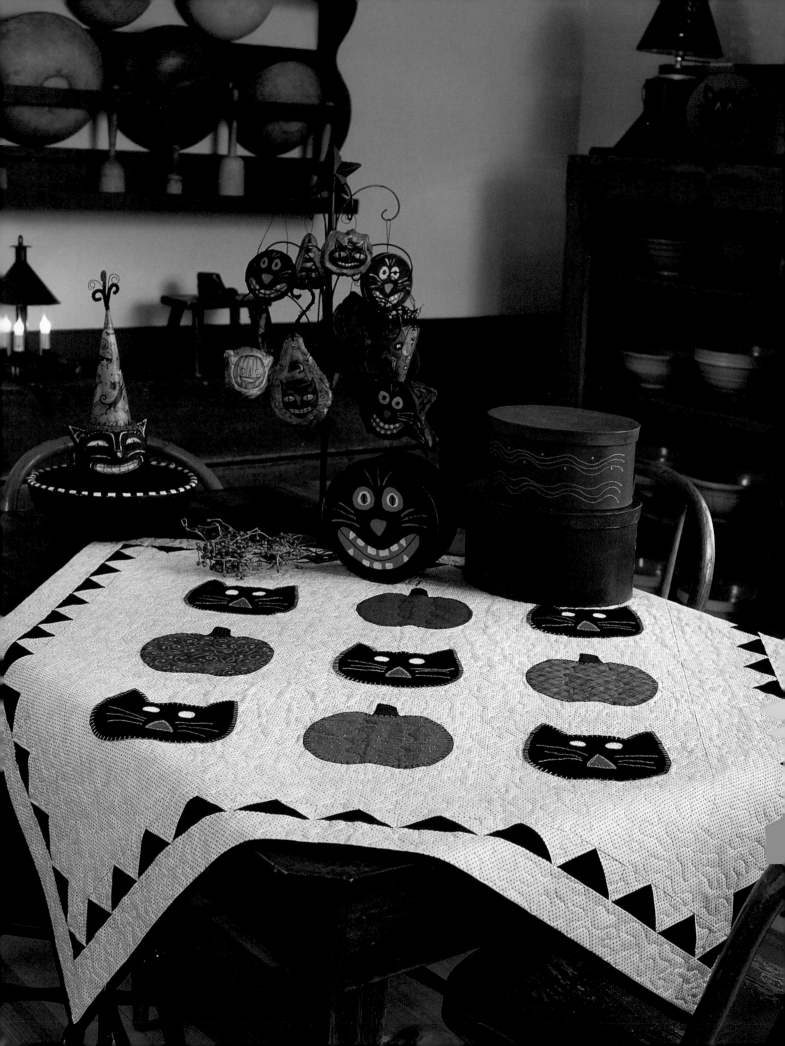

Halloween

Boo! Hang this quick-and-easy Halloween quilt near the front door to welcome trick-or-treaters. I used two strands of embroidery floss to hand sew a wide blanket stitch, giving the project a bold, folk-art look.

My husband's sister, Annie, ships us a Halloween package every year. The kids squeal in delight when they see the box on the front porch, and then groan in agony when they have to wait until Daddy gets home. Inside, we find strings of Halloween lights, pumpkin mugs, enormous spiders, and dangling skeletons. Last year we received a round, rubbery eyeball, which my son promptly threw up to our 15-foot vaulted ceiling. It stuck fast and has remained there ever since, a constant reminder that Aunt Annie loves us.—Teri

Materials

Yardage is based on 42"-wide fabric. We assume that you'll have at least 40" of usable width after prewashing the fabric and trimming the selvages.

- 2 yards of tan fabric for background
- 1 yard of solid black fabric for appliqué, border, and binding
- ¼ yard *each* of four different orange fabrics
- Scrap of dark brown fabric for pumpkin stems
- Scrap of solid muslin fabric for eyes
- 2¾ yards of backing fabric
- 44" x 44" piece of batting
- 1 yard of fusible web
- Light brown and black embroidery floss

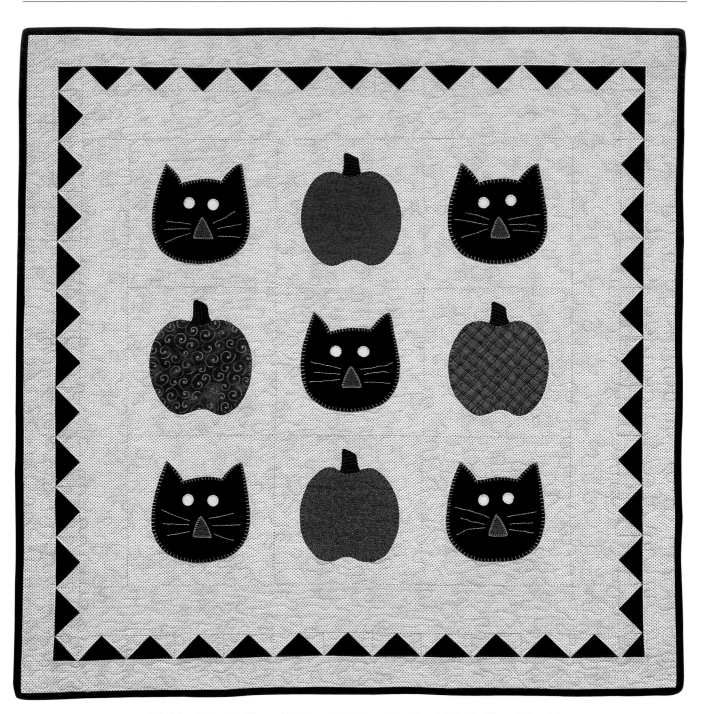

Finished Quilt Size: 40½" x 40½" • Finished Block Size: 9" x 9"

Cutting

Patterns for cat, eyes, nose, pumpkin, and stem are on pages 134–135.

From the solid black fabric, cut:

3 strips, 3½" x width of fabric; crosscut into 44 rectangles, 2" x 3½"

2 squares, 2⅜" x 2⅜"

5 binding strips, 2½" x width of fabric

5 cats

From 1 orange fabric, cut:

5 cat noses

From the solid muslin fabric, cut:

10 cat eyes

From *each* of the 4 different orange fabrics, cut:

1 pumpkin

From the dark brown fabric, cut:

4 pumpkin stems

From the tan fabric, cut:

3 strips, 9½" x width of fabric; crosscut into 9 squares, 9½" x 9½"

4 strips, 3½" x width of fabric

4 strips, 2½" x width of fabric

5 strips, 2" x width of fabric; crosscut into 88 squares, 2" x 2"

2 squares, 2⅜" x 2⅜"

Making the Blocks

1. Referring to "Using Fusible Web" on page 9, prepare the cats, noses, eyes, pumpkins, and stems for appliqué.

2. Position one pumpkin and pumpkin stem in the center of four of the 9½" tan squares. Iron to fuse in place. Use two strands of black embroidery floss to hand appliqué the edges with a ¼"-long blanket stitch.

Make 4.

3. Position one cat, two eyes, and one nose in the center of the remaining five 9½" tan squares. For each cat, I positioned one eye slightly higher than the other; on three of the cats the left eye is higher, and on two of the cats the right eye is higher. Iron to fuse in place. Use two strands of light brown embroidery floss to hand appliqué the edges with a blanket stitch. Use a ¼"-long stitch for the head and a ⅛"-long stitch for the eyes and nose.

4. Use a regular pencil to draw the whisker placement lines. The lines should not be identical—some are long, some are short, some are crooked, and some are straight. Backstitch the whiskers with two strands of light brown embroidery floss. Refer to "Embroidery Stitches" on page 10 for an illustration of the backstitch.

Make 5.

Assembling the Quilt Top

1. Arrange the five cat blocks and four pumpkin blocks as shown. The cats with a higher left eye should be on the left side of the quilt and in the center, and the cats with a higher right eye should be on the right side of the quilt. Sew the blocks together into rows and press the seam allowances toward the cats. Sew the rows together to make the quilt center. Press the seam allowances in one direction.

2. Place a 2" tan square at one end of a black rectangle, right sides together and raw edges even. Sew diagonally across the square as shown. Trim to a ¼" seam allowance and press the seam allowance toward the triangle. Repeat on the opposite end of the rectangle. Note that the diagonal slants in the opposite direction. Repeat this step to make a total of 44 flying-geese units.

Make 44.

3. Draw a diagonal line across the two 2⅜" tan squares. Place the tan squares and the 2⅜" black squares right sides together. Sew ¼" from both sides of the line. Cut on the drawn line and press the seam allowances toward the black triangles.

Make 4.

4. Sew 11 flying-geese units together, end to end. Press the seam allowances in one direction. Repeat until you have a total of four of these borders. Sew the triangle squares to the opposite ends of two of these borders, making sure that the corner squares are rotated properly to continue the zigzag pattern.

Make 2.

Make 2.

5. Trim two of the 3½"-wide tan strips to 27½" long and the other two 3½"-wide tan strips to 33½" long. Sew the 27½" strips to the sides of the quilt, and then sew the 33½" strips to the top and bottom of the quilt. Press all seam allowances toward the borders.

6. Sew the shorter flying-geese strips to the sides of the quilt, making sure that the black triangles are pointing the correct direction as shown on page 133. Sew the two flying-geese strips with the triangle squares to the top and bottom of the quilt, making sure that the black triangles are pointing the correct direction as shown. Press all seam allowances toward the tan border.

7. Trim two of the 2½"-wide tan strips to 36½" long and the other two 2½"-wide tan strips to 40½" long. (If your fabric will not give you that extra ½" to cut these strips, you can sew a piece left over from the previous trimming to each of these two strips and then cut the 40½" lengths.) Sew the 36½" strips to the sides of the quilt, and then sew the 40½" strips to the top and bottom of the quilt. Press all seam allowances toward the tan border.

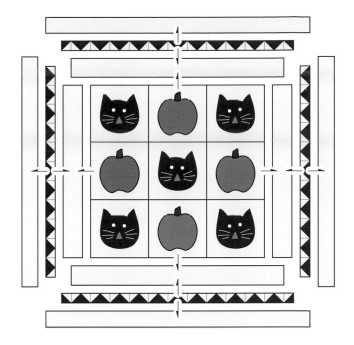

Finishing

Refer to "Quilting" on page 12 and "Binding Your Quilt" on page 13 for more detailed instructions on finishing techniques, if needed.

1. Piece the quilt backing so that it is 4" to 6" larger than the quilt top.

2. Layer the quilt top with batting and backing, and baste the layers together.

3. Quilt as desired and bind using your favorite method.

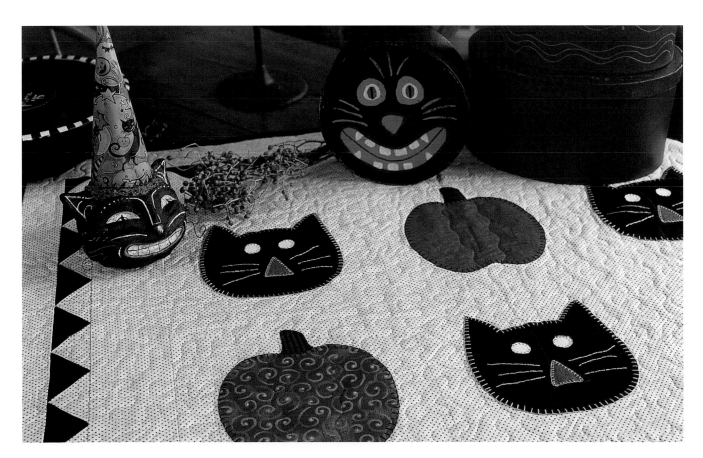

Appliqué Patterns

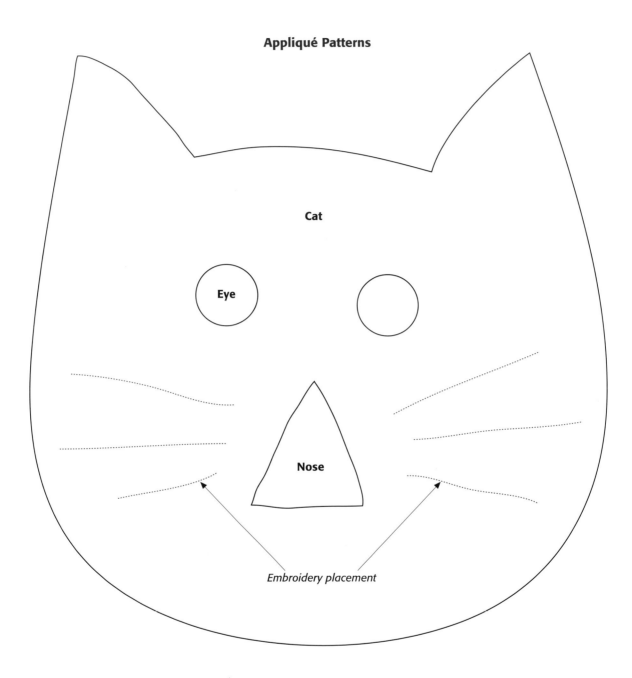

Cat

Eye

Nose

Embroidery placement

Appliqué Patterns

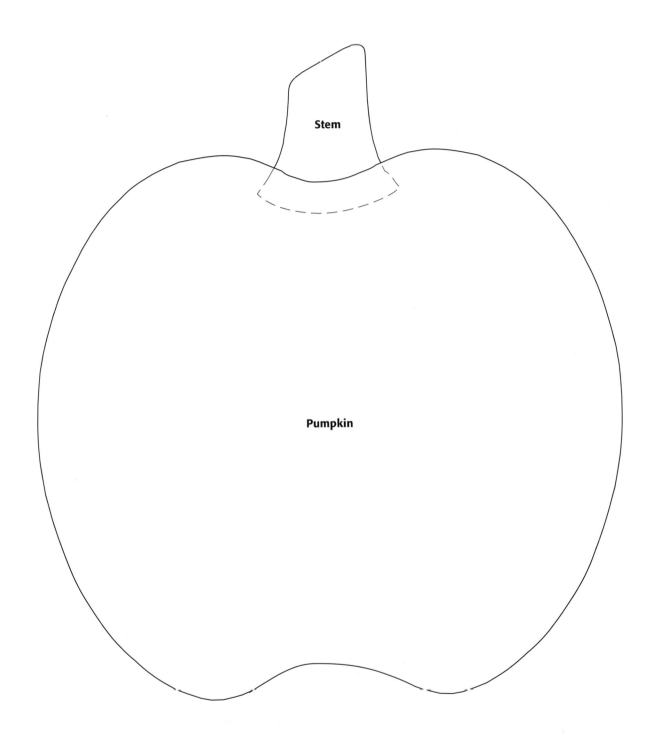

Stem

Pumpkin

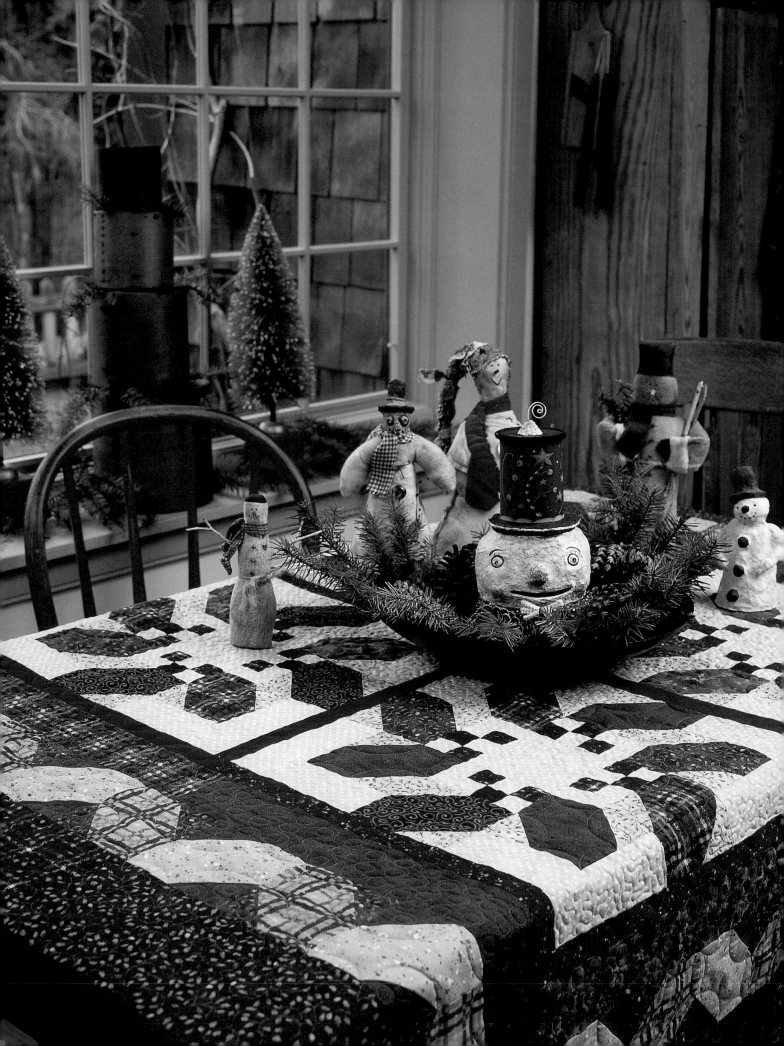

Ribbons and Holly

I just love it when a fabric is so inspiring that I can't wait to make a quilt. I bought a few bundles of the new Christmas fabric designed by my girlfriend, Nancy Halvorsen. I rushed home and went right to the washing machine to preshrink my fabric, but when I did, I discovered that I had purchased 150 tiny ⅛-yard pieces. I was so anxious to work with that gorgeous fabric, I designed the quilt anyway. Sometimes little fabric disasters force us to become more creative, but I wouldn't suggest buying fabric that way!

Quilts are a wonderful way to decorate for any season and especially the holidays. July is the best month to get started on those Christmas quilts. If you wait for the mistletoe, you'll be too late.—Barbara

Materials

Yardage is based on 42"-wide fabric. We assume that you'll have at least 40" of usable width after prewashing the fabric and trimming the selvages.

- 2¼ yards *total* of assorted red fabrics for blocks, borders, and binding
- 1½ yards *total* of assorted dark green fabrics for blocks and borders
- ¾ yard of light green fabric for blocks
- ½ yard of dark gold print for border
- ½ yard of light gold print for border
- ⅜ yard of medium light green for blocks
- 4 yards of backing fabric
- 64" x 64" piece of batting

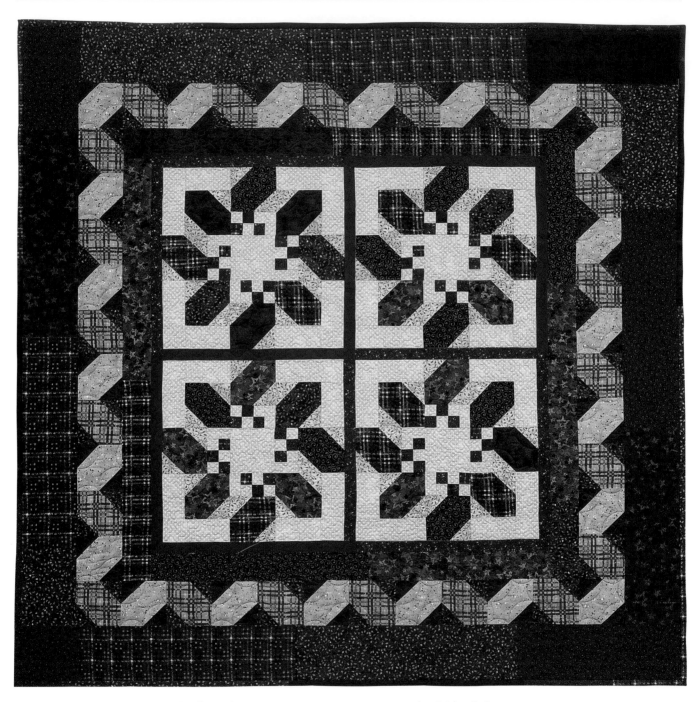

Finished Quilt Size: 58½" x 58½" • Finished Block Size: 16" x 16"

Cutting

From the medium light green fabric, cut:

4 strips, 2½" x width of fabric; crosscut into 64 squares, 2½" x 2½"

From the assorted dark green fabrics, cut:

32 squares, 4½" x 4½"

9 strips, 3" x 20"

88 squares, 2½" x 2½"

From the light gold print, cut:

3 strips, 4½" x width of fabric; crosscut into 22 squares, 4½" x 4½"

From the dark gold print, cut:

3 strips, 4½" x width of fabric; crosscut into 22 squares, 4½" x 4½"

From the light green fabric, cut:

1 strip, 6½" x width of fabric; crosscut into 16 pieces, 2½" x 6½"

2 strips, 4½" x width of fabric; crosscut 1 strip into 4 squares, 4½" x 4½", and crosscut 1 strip into 16 pieces, 2½" x 4½"

1 strip, 2½" x width of fabric; crosscut into 16 pieces, 1½" x 2½"

3 strips, 1½" x width of fabric

From the assorted red fabrics, cut:

12 strips, 5½" x 20"

3 strips, 1½" x 40"

2 pieces, 1½" x 16½"

3 pieces, 1½" x 33½"

2 pieces, 1½" x 35½"

14 binding strips, 2½" x 20"

Making the Blocks

1. Place a 2½" medium light green square at one corner of a 4½" dark green square, right sides together. Sew diagonally across the light green square. Trim to a ¼" seam allowance and press the seam allowance toward the triangle. Repeat on the opposite corner. Repeat this step to make a total of 32 holly leaf units.

Make 32.

2. Repeat step 1 using the 22 light gold squares and the 2½" dark green squares. Repeat again with the 22 dark gold squares and the 2½" dark green squares. You will have a total of 44 ribbon units.

Make 22. Make 22.

3. Sew a 1½"-wide light green strip between two 1½" x 40" red strips, lengthwise. Press the seam allowances toward the red strips. Cut the strip set into sixteen 1½"-wide red units.

1½"

Make 1 strip set.
Cut 16 segments.

4. Sew a 1½" x 40" red strip between two 1½"-wide light green strips, lengthwise. Press the seam allowances toward the red strip. Cut the strip set into sixteen 1½"-wide light green units.

Make 1 strip set.
Cut 16 segments.

5. Sew each red unit to a light green unit as shown and press the seam allowance toward the red units. Sew a 1½" x 2½" light green piece to one end of each unit as shown to make 16 berry units. Press the seam allowance toward the light green pieces.

Make 16.

6. Sew each berry unit to the bottom of a holly leaf unit, as shown, to make 16 berry sections. Press the seam allowance toward the leaf units.

Make 16.

7. Sew a 2½" x 4½" light green piece to the top of the remaining holly leaf units as shown. Press the seam allowance toward the light green. Sew a 2½" x 6½" light green piece to

the left side of the holly leaf units as shown. Press the seam allowance toward the light green.

8. Sew a 4½" light green square between two berry sections and press the seam allowance toward the light green square. Make a total of four of these center sections.

Make 4.

9. Sew a berry section between two holly leaf sections as shown. Press the seam allowance toward the leaf sections. Make a total of eight of these side sections.

Make 8.

10. Sew two side sections and one center section together to make each block. Press the seam allowances toward the side sections.

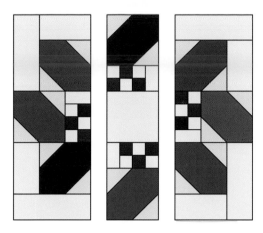

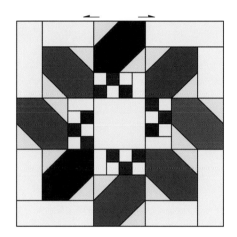

Make 4.

Assembling the Quilt Top

1. Join two blocks with a 16½"-long red piece to make each row. Press the seam allowances toward the red strip. Join the rows with a 33½"-long red piece and press the seam allowances toward the red strip.

2. Sew a 33½" red strip to each side of the quilt and then sew a 35½" red strip to the top and bottom of the quilt. Press all seam allowances toward the red strips.

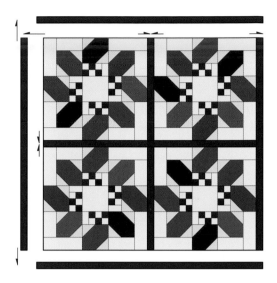

3. Sew the nine 3" x 20" dark green strips together, end to end, to form the scrappy borders. From this pieced strip, cut two border strips 35½" long and two border strips 40½" long.

4. Sew the 35½" strips to the sides of the quilt, and then sew the 40½" strips to the top and bottom of the quilt. Press all seam allowances toward the green border.

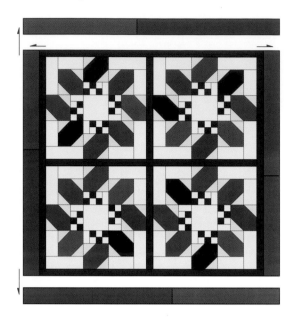

5. Sew five light gold ribbon units to five dark gold ribbon units as shown, alternating light and dark colors. Press the seam allowances in one direction. Repeat to make two side borders. Repeat this step with six light gold and six dark gold ribbon units per strip for the top and bottom borders.

Make 2.

Make 2.

6. Sew the side ribbon borders to the quilt, and then sew the top and bottom ribbon borders to the quilt as shown. Notice the placement of the light and dark units. Press all seam allowances toward the green border.

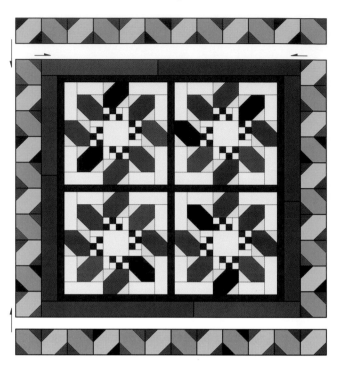

7. Sew the 12 red 5½" x 20" strips together, end to end, to form the scrappy outer border. From this pieced strip cut two border strips 48½" long and two border strips 58½" long.

8. Sew the 48½" strips to the sides of the quilt, and then sew the 58½" strips to the top and bottom of the quilt. Press all seam allowances toward the red border.

Finishing

Refer to "Quilting" on page 12 and "Binding Your Quilt" on page 13 for more detailed instructions on finishing techniques, if needed.

1. Piece the quilt backing so that it is 4" to 6" larger than the quilt top.

2. Layer the quilt top with batting and backing, and baste the layers together.

3. Quilt as desired.

4. Sew the 14 red binding strips together, end to end, to form a scrappy binding. Attach the binding to your quilt using your favorite method.

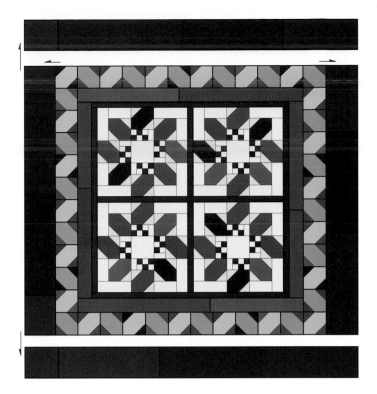

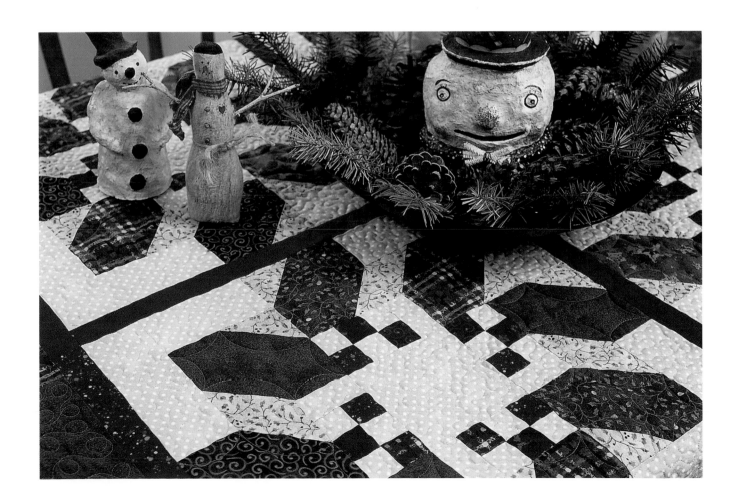

About the Authors

Barbara Brandeburg
of Cabbage Rose

Barbara Brandeburg grew up in Southern California in a world of sewing, creativity, and art, along with her five sisters and one brother. She made her first quilt at age 19 using dime-store fabric, inventing the instructions and techniques as she sewed. Her years as a young mother were spent sewing traditional pieced quilts and home-decorating projects, using her natural ability to "just figure it out" without a book or class.

In 1994 Barbara launched her pattern company, Cabbage Rose, selecting the name because of her love of decorator floral prints. The year 2004 marks Barbara's tenth year in business—a business that includes a list of publications that has grown to 16 books and 36 patterns, as well as the release of a third fabric line. Barbara loves designing and can't wait to spend her time creating something new and fun. She loves family life in the vineyard country of Northern California with her husband, John, and 17-year-old daughter, Katie. Her son, Travis, is away at college.

Teri Christopherson
of Black Mountain Quilts

Teri Christopherson loves quilting because it allows her to play with color—and to buy all the fabric she wants! Her passion was born when her mother taught her, at age five, to use the sewing machine. She taught herself to quilt during her college years. She spent more time cutting out squares than studying for midterms—which actually served her well. Later, as a young mother in search of a home business, she began selling her quilts in country stores. Business was so good that soon she and her sister Barbara were quilting night and day to keep up with the demand.

In 1993, Teri began publishing her original quilt designs. To date, she has published 17 books and 27 patterns, with more continually on the way.

When she's not quilting, Teri loves reading; she belongs to two book clubs. She also enjoys home decorating, gardening, crochet, cross-stitch, and volunteering at church. She and her husband, Mark, have four children.